BAMBOO
BASKETS

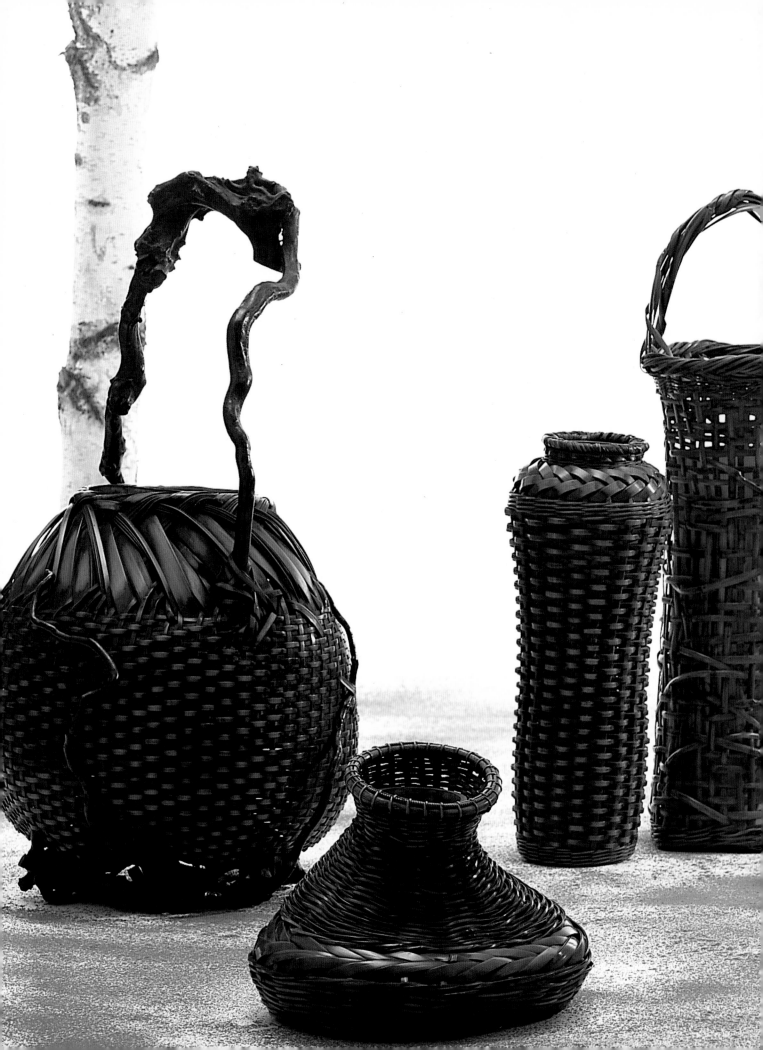

BAMBOO

Japanese Art and Culture Interwoven with the Beauty of Ikebana

BASKETS

BY

MAGGIE OSTER

PHOTOGRAPHY

MARK SEELEN

IKEBANA ARRANGEMENTS

YI-AN CHOU

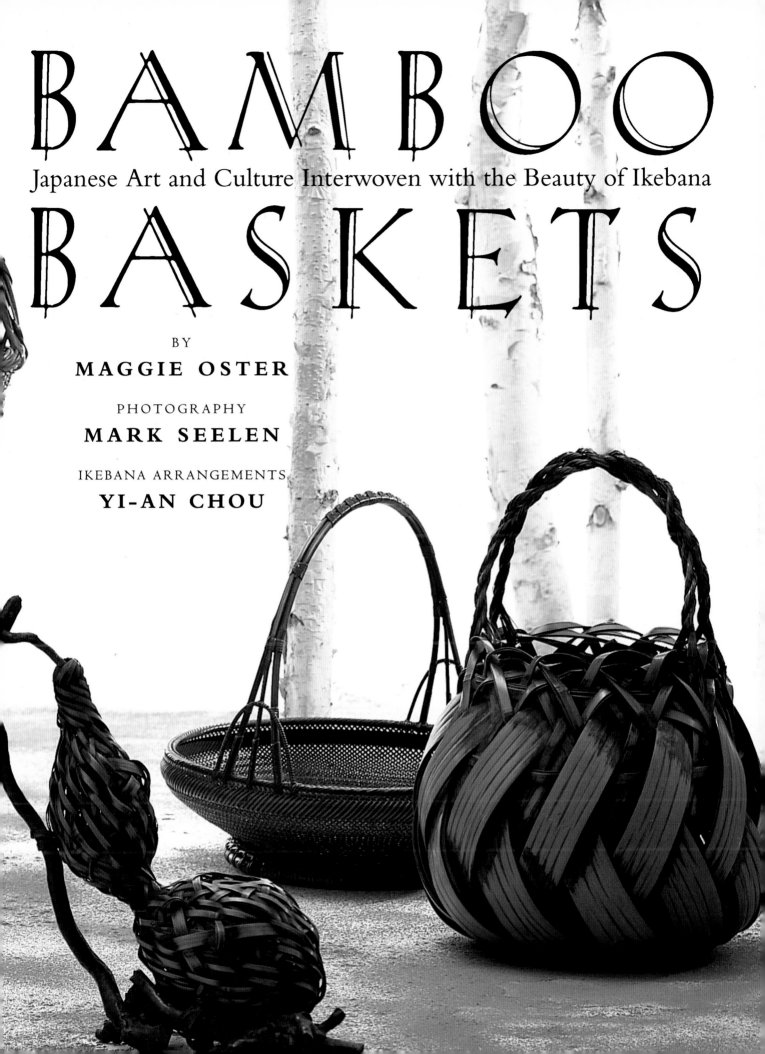

A Packaged Goods Incorporated Book

Conceived and produced by
Packaged Goods Incorporated
276 Fifth Avenue
New York, New York, 10001
A Quarto Company

VIKING STUDIO BOOKS
Published by the Penguin Group
Penguin Books USA Inc.,
375 Hudson Street,
New York, New York, 10014, U.S.A.

Penguin Books Ltd,
27 Wrights Lane,
London W8 5TZ, England

Penguin Books Australia Ltd,
Ringwood, Victoria, Australia

Penguin Books Canada Ltd,
2801 John Street,
Markham, Ontario,
Canada L3R 1B4

Penguin Books (N.Z.) Ltd,
182-190 Wairau Road
Auckland 10, New Zealand

Penguin Books Ltd, Registered Offices:
Harmondsworth, Middlesex, England

First published by Viking Studio Books,
an imprint of Penguin Books USA Inc.

Text by Maggie Oster
Photography by Mark Seelen
Design by Yasuo Kubota, Kubota & Bender
Ikebana arrangements by Yi-An Chou
Editor: Kristen Schilo
Art Coordinator: Margaux King

First printing October 1995
10 9 8 7 6 5 4 3 2 1

Library of Congress Catalog Card Number: 95-60098

ISBN: 0-14-024341-0 (paperback),
0-670-86187-1 (cloth)

Color Separations by Wellmak Printing Press Limited
Printed and bound in Hong Kong by
Sing Cheong Printing Co., Ltd.

Acknowledgments

DROUGHT BURNS BASINS TO DUST,
LIGHT RAIN IS A DEW OF MOCKERY.
RECEIVE WITHOUT COMPLAINT,
WORK WITH FATE.

DENG MING-DAO

Gifts come in many forms to our lives, if we are open and willing to accept them. Such is this book for me, recalling as it has my beliefs, values, and path. For this, my gratitude to the editors Cyril Nelson and Kristen Schilo, and to the tireless efforts of Ted Gachot, Tatiana Ginsberg, Lillien Waller, and Margaux King. Speaking volumes in this book are the ikebana arrangements by Yi-an Chou, photography by Mark Seelen, and design by Yasuo Kubota. They have brought beauty to life, and this is truly their book.

Bamboo Baskets would not have been possible without the considerable assistance of the knowledgeable individuals at the galleries, specialty stores, gardens, and other cultural centers that contributed to this book: Our thanks to Marilyn and James Marinaccio, Lindel Gum, and Veronique Hepp at Naga Antiques, Ltd.; Sally Pleet and Lorraine Levitz at Things Japanese; Lisa Bradkin at Takashimaya America, Inc.; Amie Belobrow at Old Japan, Inc.; Jean and Cliff Schaefer, and Anthony Blower at Flying Cranes Antiques, Ltd.; Steve Morrell at the John P. Humes Japanese Stroll Garden; Roni Neuer at Ronin Gallery; Hisashi Yamada at the Urasenke Chanoyu Center; Nancy Moore Bess; and Bonnie and James Udell.

I am grateful for the friendship and support of Shizuko Hasegawa as well as for the books lent by her and Kitty Strube. For day-to-day sustenance of spirit, thank you Ilze Meijers, Kurt Hampe, and Lucille Oster.

STORM BREAKS INTO PIECES,
CLOUDS CHARGE THE HORIZON
REVOLVING OF THE HEAVENS
GENERATES ALL MOVEMENT.

DENG MING-DAO

Contents

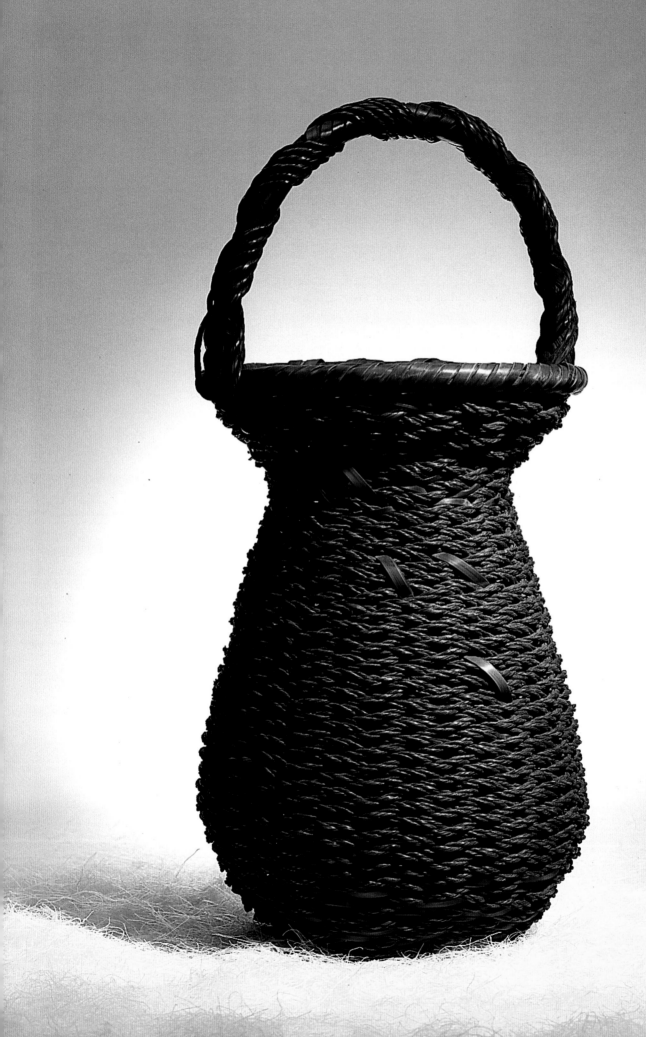

INTRODUCTION

A bamboo basket, small and asymmetrical, holding beautifully arranged flowers in perfect balance, sat alone in an alcove. It commanded my eye to rest, to absorb its shape and texture, to know its ancient secrets. At that moment, twenty years ago, when visiting the villa of a Kyoto tea master, I recognized the Japanese basket as a powerful art form that evolved from a long heritage of ceremony, cultural refinement, and diligent craftsmanship. Since that initial introduction, the quest for exceptional baskets for my gallery of Japanese art, Naga Antiques Ltd., continues to rekindle my love for these fascinating objects. The variety of weaves, shapes, textures, and knots, and the sculptural use of natural elements (in handles, for example), make Japanese baskets endlessly interesting.

The history of Japanese baskets dates back to the Muromachi period (1392-1568). It was then that the Buddhist monastery ritual of drinking tea, which originated in China some centuries earlier, was imparted to Japan's ruling classes, who developed a great appreciation for all objects used in its preparation. Through the years, and regardless of class, the art of the tea ceremony grew immensely in popularity all over the country, with the literati setting the trends. The bamboo basket became the essential flower container for the summer months, with its airy weave portraying the lightness of the season. A well chosen arrangement could enhance the enjoyment of taking tea by transporting its viewer to other spiritual or sensual realms. Many different basket designs and techniques were brought to life to satisfy a variety of tastes and visions. The delicate patterns of the early Chinese baskets, the unrestrained purely Japanese forms, and even the fishing creel or "folk" basket, favored by the great sixteenth-century tea master, Sen no Rikyū, emerged from the creative hands of the basket makers.

Maggie Oster leads you with sensitivity throughout the historical journey of the Japanese basket. The cultivation and preparation of the bamboo, the techniques and skills of the basket makers, the variety and styles of the flower-arranging schools, are presented in this book as intricately and exquisitely as the subject itself. Once captivated by the art of Japanese basketry you will remain, as I am, forever in its thrall.

April 17, 1995

Marilyn Marinaccio

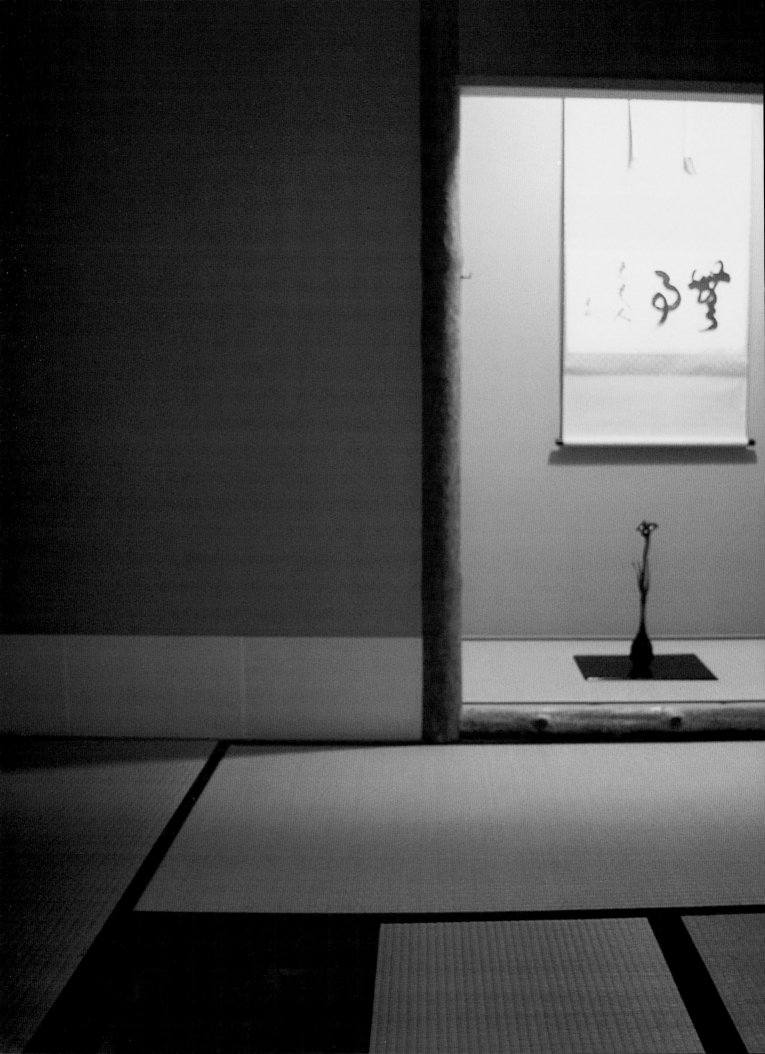

Aesthetics
of
Simplicity:
Tea,
Baskets,
and
Flowers

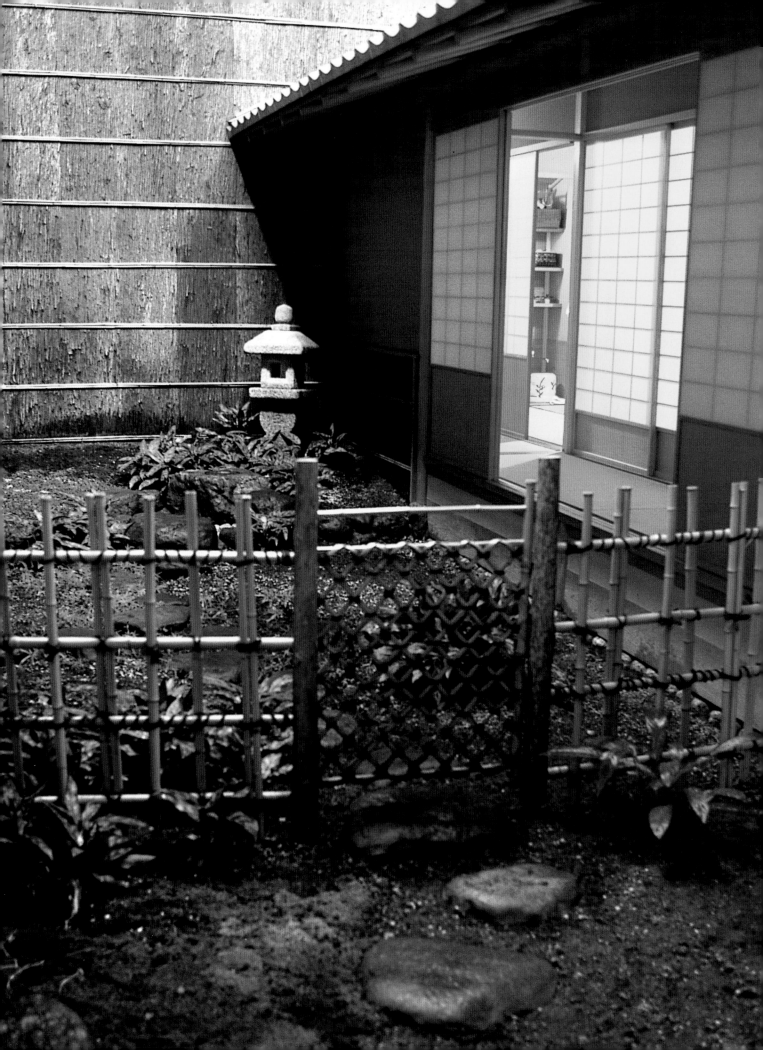

In this world, there are any number of paths to finding inner peace, to penetrating the nature of the eternal, to developing a criteria for living and a discovery of one's self. Among the many ways is the Way, the Japanese concept of learning and mastering the traditions of an art. Through this effort the body, mind, and spirit are brought into harmony, the self is brought closer to the perfect, and a person is able to find inner calm in the face of outer turmoil.

The various Ways, the arts, are at the heart of the cultural, intellectual, and philosophical life of Japan. Based on the practice of traditions passed from generation to generation, serenity is found in the focus needed to perfect the form and proportion of the art. A Way is learned slowly by strictly adhering to methods that have stood the test of experience and time. Only when these are mastered, and self-will has been conquered, does the freedom for personal creativity arise spontaneously from within. Rather than confining, the strictures offer a foundation for true organic growth that both honors the past and allows for change.

The harmonious setting of a tea room beckons us on a path of tranquillity by a renewal of purpose and self amid the struggles of life.

As with many aspects of Japanese life, the different Ways are sometimes interconnected. Two of the most popular, the Way of Flowers, *kadō*, and the Way of Tea, *chadō*, are closely linked and have greatly influenced each other over hundreds of years. The history of bamboo baskets is intimately interwoven with these two Ways. Taken together, they can offer us insight into a way of living. To study and appreciate bamboo baskets, we should also look at Japanese flower

arranging, the tea ceremony, and the geography, history, and spiritual philosophies of Japan.

Primitive in origin, a basket in any culture is intrinsically a functional object. Japanese baskets have survived from as far back as the third century B.C. Although bamboo is not the only material used for basketry in Japan, its geographical range and quantity, and its inherent qualities of strength, lightness, and ease of use have caused baskets made of bamboo to be preeminent. Through the centuries, the characteristics of bamboo have offered not only function but beauty in baskets of every possible shape, form, and use, to people at all levels of society from birth to death.

Geographically, Japan is an isolated archipelago of volcanic islands. Since its earliest times, Japan has wrought considerable control over the influx of foreign influences. Throughout history, the Japanese have borrowed and adapted from other cultures yet have retained and asserted a unique cultural identity.

At once lush and austere, Japan is a country of people closely linked not only to the land but to nature's whims. The indigenous religion of Shintoism is one of purity, revering the spirit, or *kami*, of all things. About a third of Japan's most ancient poetry deals with flowers and plants. The oldest account of Japan, the *Nihon Shoki* says "every plant can express itself" and tells of seasonal flowers being offered at the tomb of a goddess to solace her spirit. Shintoism also stresses sincerity, gratitude, joy, awe, and ritual.

In passing on the traditions of an art from master to student, the mature is brought into contact with the new and unformed. An in and yo relationship, the resulting "wholeness" is essential to the further development of the art.

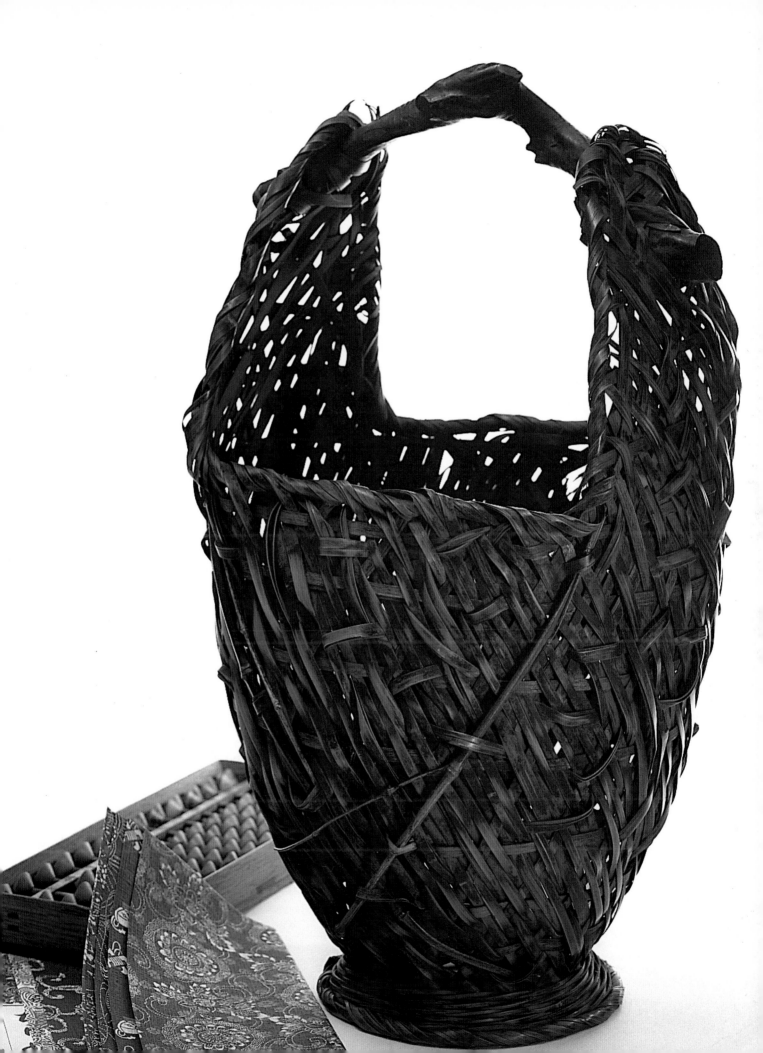

Buddhism was introduced to Japan in the sixth century. Coming from China through Korea, it was strongly laced with Confucianism and Taoism. Confucianism contributed a basis for morality and ethics. Taoism emphasized the Oneness wrought by the *yin* and *yang*, or *in* and *yo*. It was from this confluence of Shintoism, Buddhism, Confucianism, and Taoism that Japanese culture took its form.

The Way teaches that the essence is not in the external value of an object, but in the attitude of mind and spirit that grasps the Oneness of all things. A basket is no less beautiful if it is primarily functional rather than artistic when the artist has allowed the basket to mirror his soul.

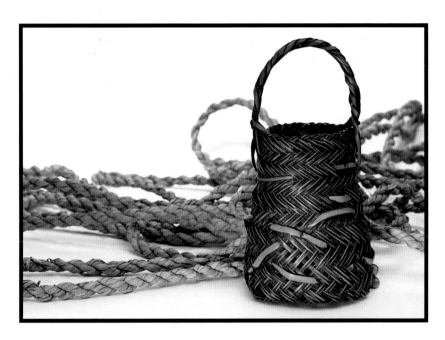

Predicated on meditation as the principal method of attaining enlightenment, Buddhism, especially the Zen sect, emphasizes tranquillity and a recognition of the underlying unity and transitory nature of all things. Along with mental concentration, Zen Buddhism bases aesthetic value on the harmony between the artist's concept, his sensitivity to the chosen medium, and his mastery of the technique.

From its earliest days in India, Buddhism has many connections to flowers. Buddha is said to have been born surrounded by fragrant flowers of the field, and is typically depicted on a large lotus flower. The Indian practice of

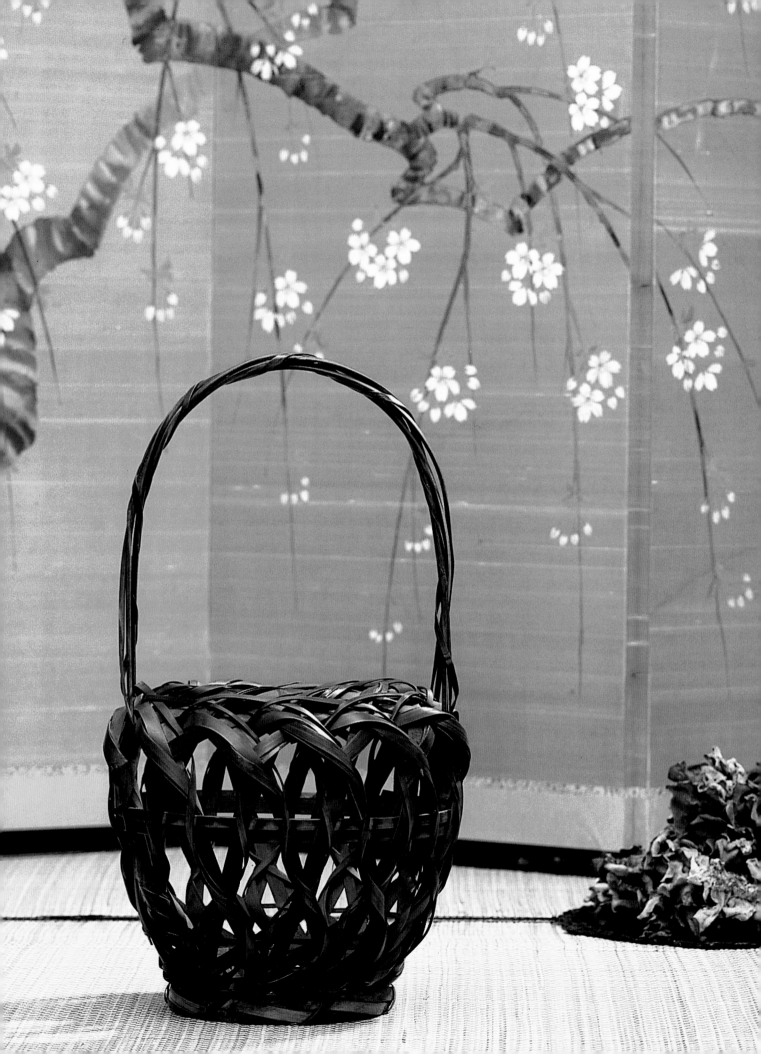

IN THE LANTERN LIGHT
 WHITE ARE THE TEA PLANT BLOSSOMS
BY THE PATH AT NIGHT.

 HEKIGODO

The brief effusion of cherry
blossoms is a reminder that
all is ephemeral. We have
only a moment to enjoy the
beauties of this earth.

placing water-filled vases with plant cuttings on altars to Buddha was continued in Japan, where the priests made simple upright arrangements. Besides the early upright altar arrangements, usually in bronze hourglass-shaped vases, flowers were also presented in temples using baskets and shallow bowls or basins.

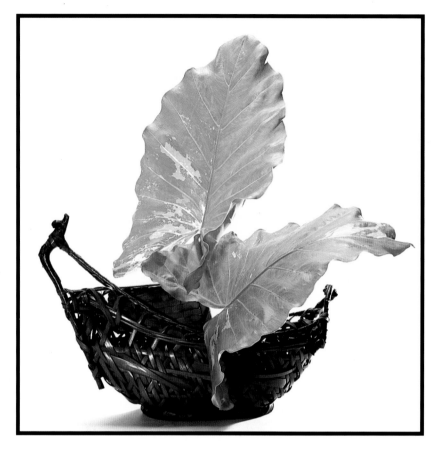

To become one with bamboo, then to forget that you are one with it, is at the heart of the Zen approach to discipline and creativity. Allowing the bamboo to speak, the artist finds sculpture in the use of wide strips, or in the basket's ultimate shape.

More than five hundred bamboo baskets, many of which were for holding flowers and petals, are preserved from the Nara period (*circa* 710-794).

Into the fourteenth century, arrangements continued to be basically an elaboration of the straight, upright style, or *rikka*. Using bronze or porcelain containers, arrangements consisted of a dominant central branch, often of the sacred Shinto evergreen, *sakaki*, surrounded by six or eight smaller branches or flowers. Practitioners were mainly priests, men of nobility, and *samurai*, or warriors. During this time, flower masters began delineating and recording principles, definitions, and parameters for flower arranging.

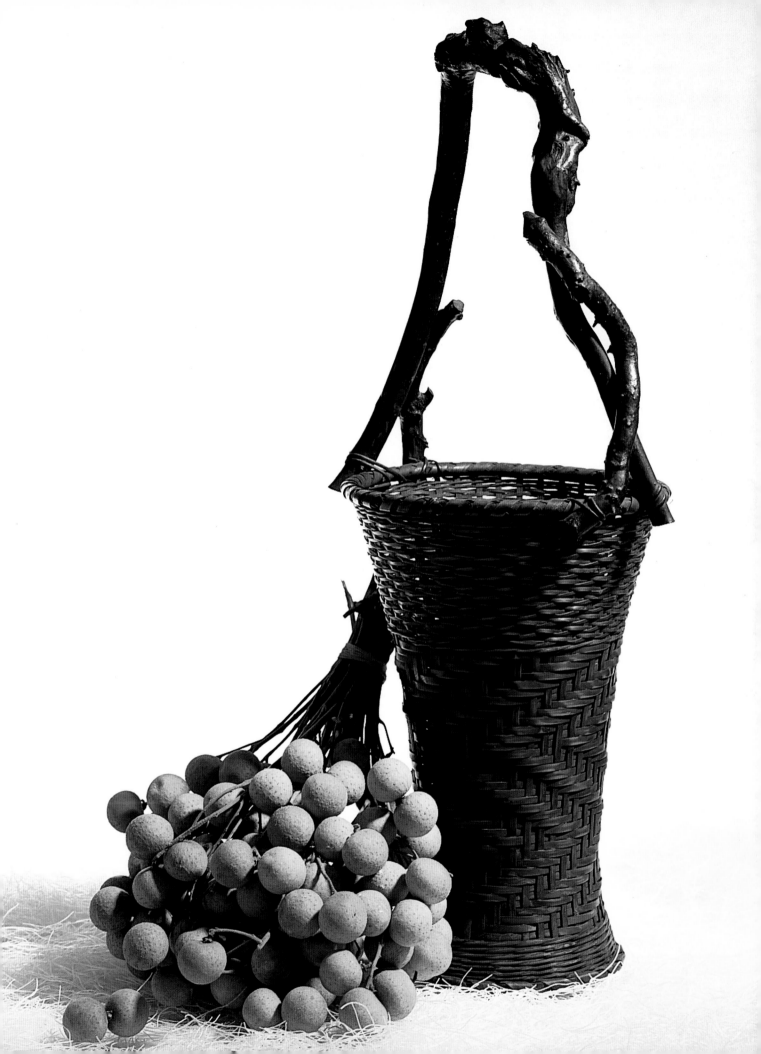

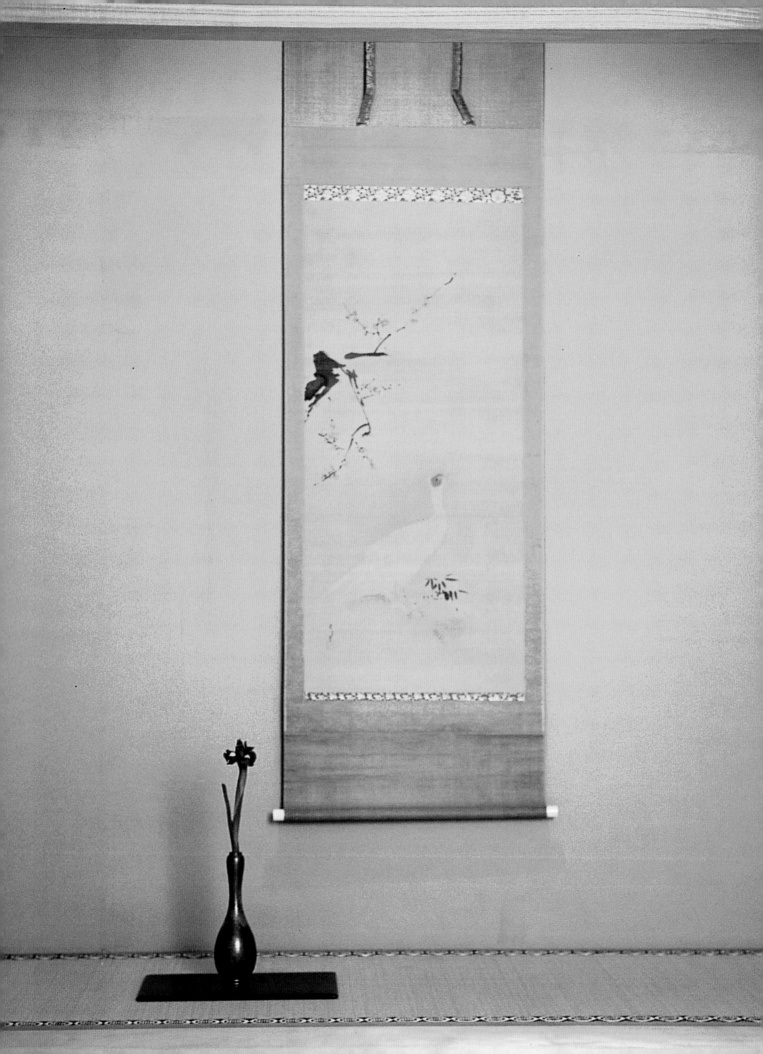

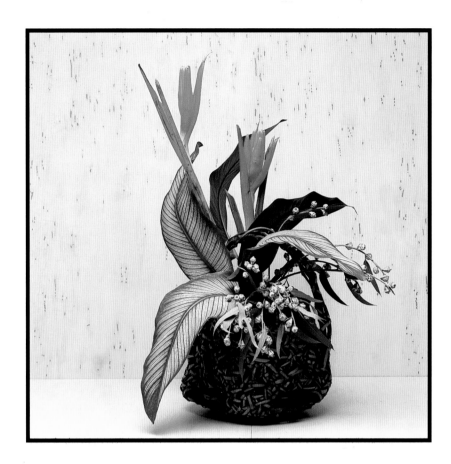

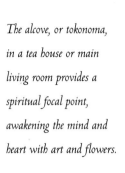

The alcove, or tokonoma, in a tea house or main living room provides a spiritual focal point, awakening the mind and heart with art and flowers.

In the Muromachi period (*circa* 1392-1568), Zen Buddhism's focus on simplicity influenced builders to develop the *shōin*, or "study," style of architecture, which is the precursor of the traditional Japanese house. A significant feature of the *shōin* was the alcove, or *tokonoma*, in which painted scrolls, sculpture or flowers, and incense were displayed. An outgrowth of religious shrines in monasteries, the *tokonoma* retained an aura of reverence while becoming the place to showcase art.

The wealthy, powerful, and noble devoted the *shōin* to culture, parties, and the evolving ritual centered around drinking powdered green tea, or *matcha*. Many of the art objects, including baskets, admired in the *shōin*, were of Chinese origin or style. These baskets were elegant and symmetrical with elaborate plaitings of narrow bamboo strips. The Shogun Ashikaga Yoshimasa (1436-1490) is credited with being the first person to use a basket with flowers in the *tokonoma*.

Responding to the Zen precept of minimalism, a segment of society sought a more restrained tea ceremony removed to more tranquil surroundings. Preferably, this was a small, plain, rustic hut with a garden leading to it that resembled a mountain path along which guests left worldly cares behind. The tea ceremony, *chanoyu*, as codified by the great tea master Sen no Rikyū (1521-1591), has pervaded nearly every aspect of Japanese culture, from its architecture to art, food, and etiquette. A tearoom is unpretentious, human in scale, and made of natural materials. Stressing humility, the tea is prepared with an intricate bamboo whisk by the host but only guests partake, one after another, sharing the bowl to create a sense of community. The host has given much careful thought to the flowers and scroll in the *tokonoma* as well as to the tea utensils, with each item expressing his taste and cultivation. It is each guest's role to recognize and appreciate them. Comments are exchanged about the tea utensils, room decor, flower arrangement, hanging scroll, garden, and season. The spirit is that of *ichigo-ichie*, "one time—one meeting," that this opportunity

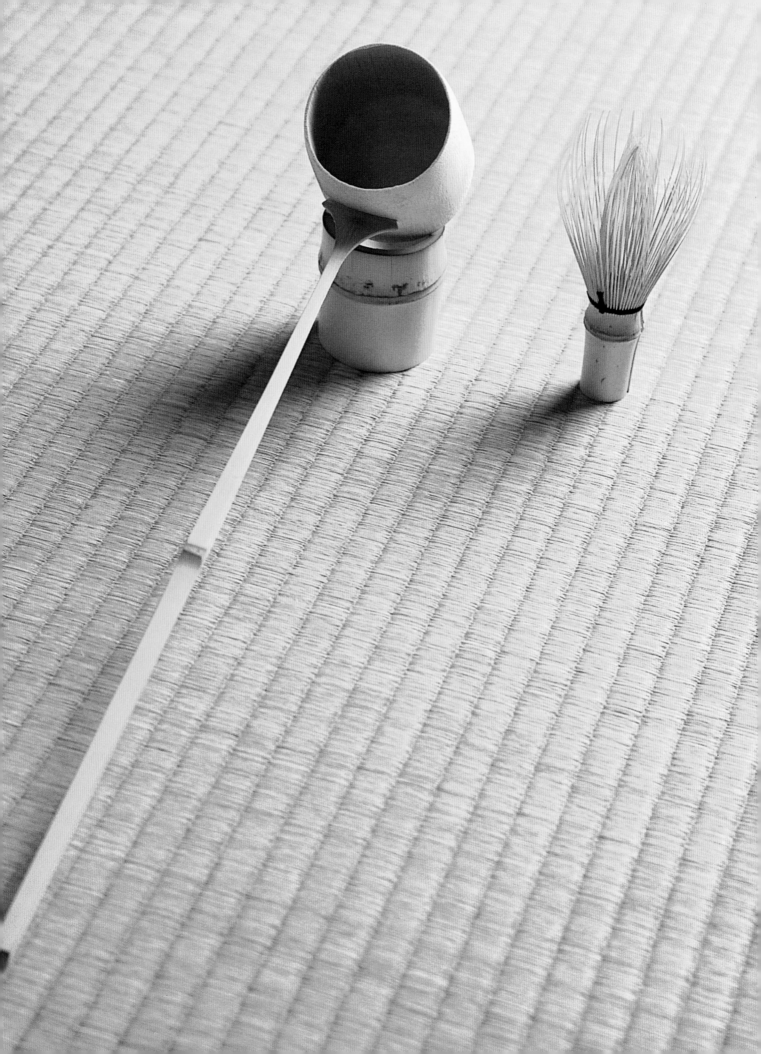

may come only once and therefore is not to be taken lightly. From the guiding principles of harmony, respect, purity, and tranquillity, the *matcha* of *chanoyu* slakes the thirst of the mind, body, and spirit.

Although the *tokonoma* continued to play a key role in the ceremony, Rikyū felt an entirely different style of flower arranging from *rikka* was needed. Known as *chabana*, "tea arrangement," this style was characterized by using only one or a few light-colored flowers naturally arranged, according to Rikyū, "as if they were growing in a field." As with his choice of paintings and tea wares, Rikyū preferred simple flower containers, from a length of bamboo stem to plain ceramic or bronze vases and rustic baskets called *wagumi*. These baskets were often asymmetrical, soft in feeling, and made with wide bamboo strips.

Rikyū felt that the most important factor in the tea ceremony and flower arranging was the person's state of mind. A well-known tale illustrating *chabana* is that of Rikyū and the Shogun Hideyoshi Toyotomi. The morning glories in Rikyū's garden were considered exemplary, but when the shogun arrived he saw none. Upon entering the tea ceremony room, a single morning glory, beautifully arranged, greeted him, thus symbolizing the entire garden.

During the late seventeenth and early eighteenth centuries, the *chōnin*, or merchant class, rose in economic power and cultural influence, and both the tea ceremony and flower arranging became popular among them. With this expansion of interest, different schools of tea and flowers appeared, each with varying interpretations. Basket makers, too, experimented with a wider range of styles, both for their own satisfaction as well as to accommodate the many new forms that flower arranging was taking.

To produce a basket, whether a delicate and intricately woven one in the karamono, "Chinese object" style, or a rustic wagumi, requires many hours of laborious preparation. The bamboo must be washed, dried, leached, split, stripped, and cut before the basket is begun.

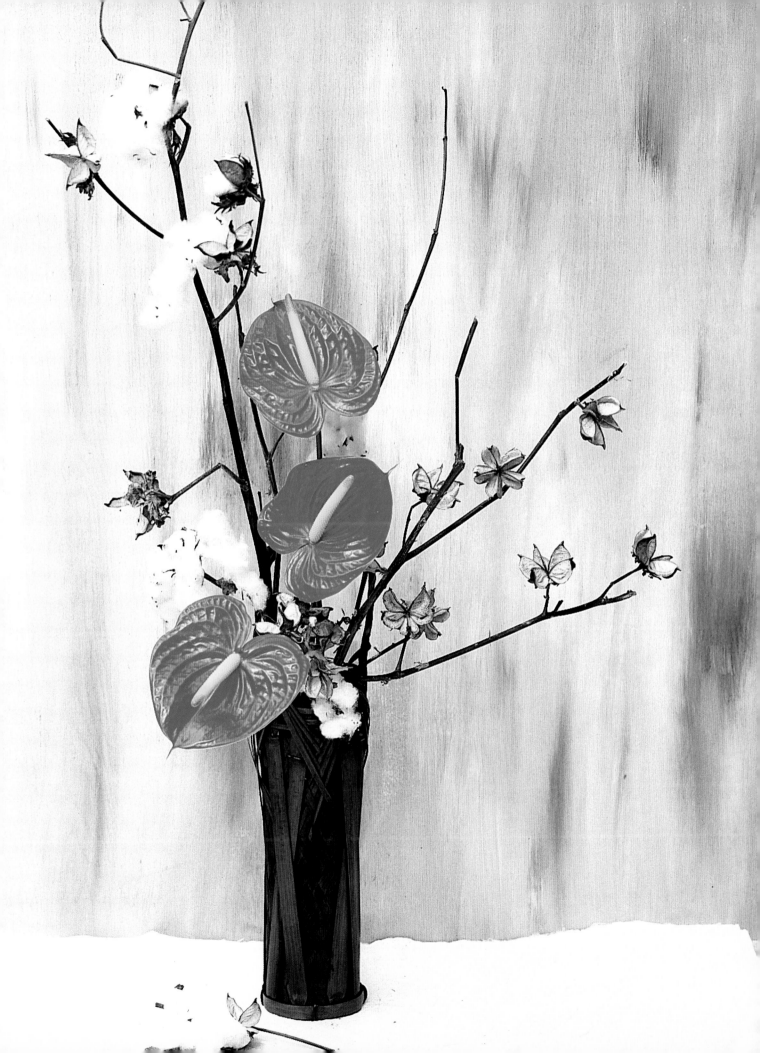

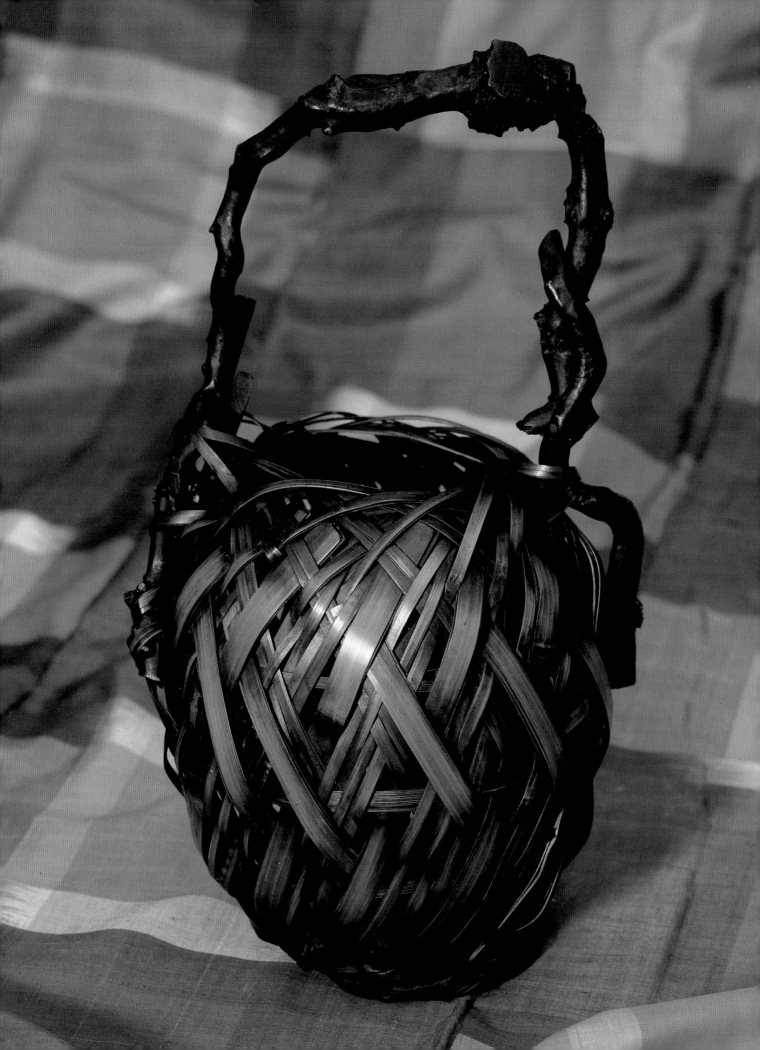

With Japan opening itself to the West in the nineteenth and twentieth centuries, the traditional arts were once again affected by outside influences. Yet because of their heritage and traditions, the Japanese were able to incorporate aspects of other cultures into their own without losing sight of their unique aesthetic sense. While exploring new means of expression, they never abandoned the essence of their arts, and were once again able to bring the past and present into harmony.

The expressionistic but balanced utilization of irregular plaiting is dependent on the artist's skill and intuition.

Having evolved from the interweaving of natural and spiritual forces with art and culture, the various Ways encourage the integration of *sabi, wabi, aware,* and *yūgen* into one's being, so that they become as breathing. *Sabi* is the feeling of isolation or detachment. *Wabi* is the spirit of poverty, or the appreciation of the commonplace, the celebration of the humble and handmade. *Aware* is the acceptance of the impermanence of things. *Yūgen* is the sense of mystery endemic to all of life.

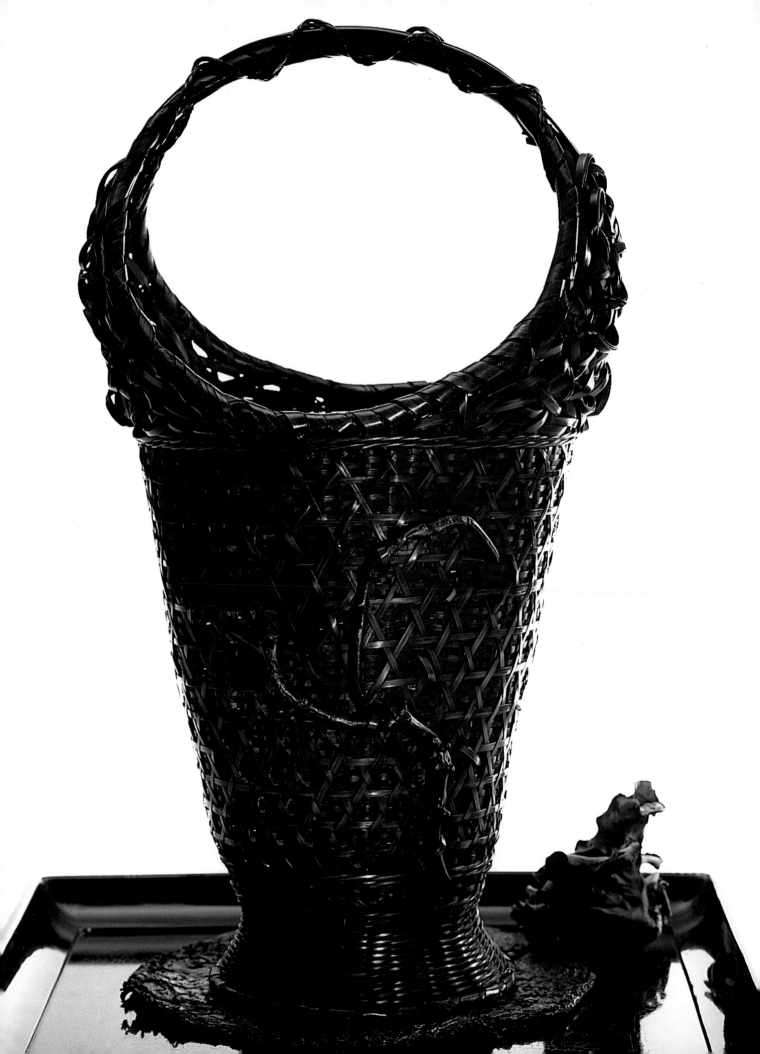

The assimilation of these four aspects into the Japanese character has given the world not only centuries of beautiful objects but a manner of approaching life centered around simplicity. This elimination of the unnecessary is evident in many of the arts of Japan. It is seen in sparse paintings of a few black lines on white paper, poetry of a few controlled syllables, and drama marked by the avoidance of gesture. Similarly, in bamboo baskets and flower arrangements we find a deeper meaning springing from intuitive perception rather than reasoning and leading to the essence, or heart, of ourselves and our world.

Only with the interweaving of detachment, appreciation of the humble, acceptance of the ephemeral, and acknowledgment of life's mysteries is one able to reach the truth of things, touching the deepest recesses of one's being and allowing for creativity.

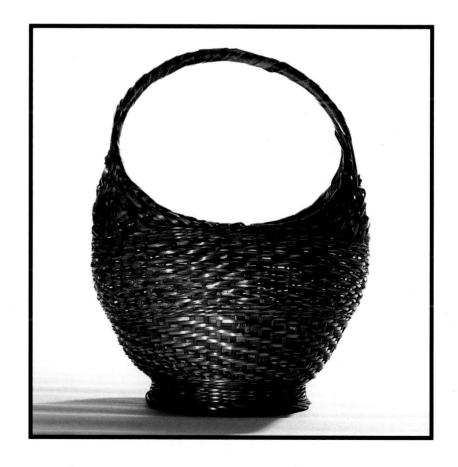

CAST BY MORNING LIGHT,

 THE STAMEN'S SHADOW IS BLACK

 ON THE CALLA WHITE.

 SHŌSON

Art in Japan is an expression of temporary enlightenment, that moment when the artist sees into the life of things. With the haiku's seventeen syllables, a drawing's few brush strokes, or a basket's simple bamboo plaiting, the artist has created from a point of awakened unconsciousness.

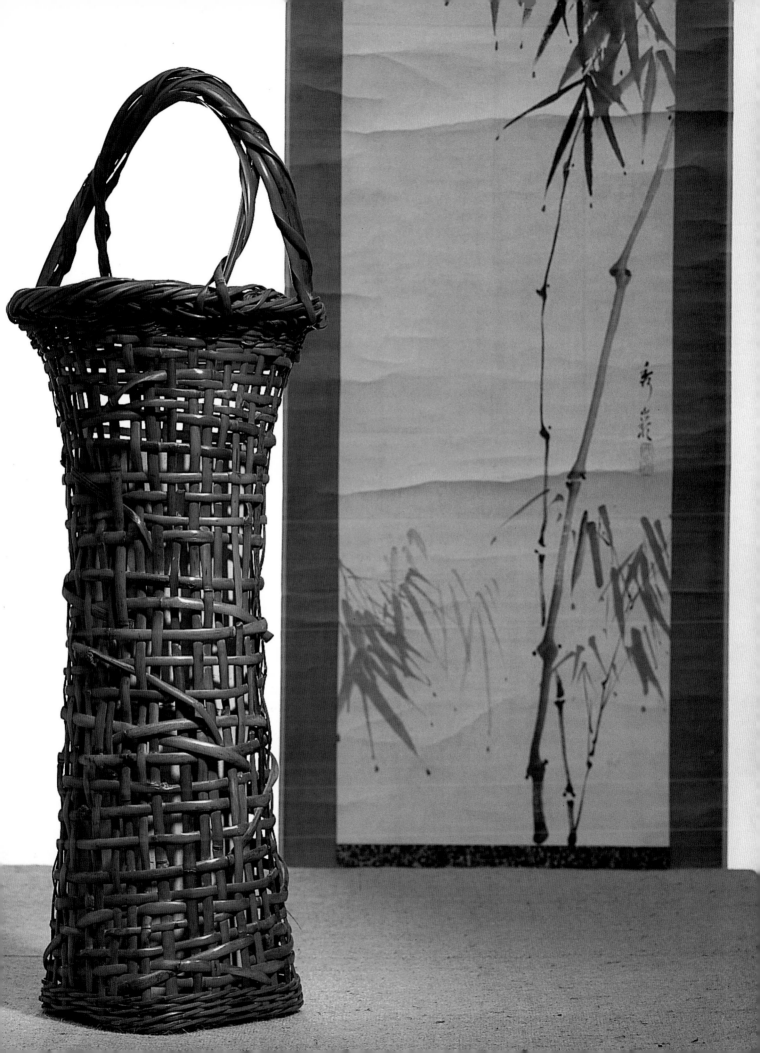

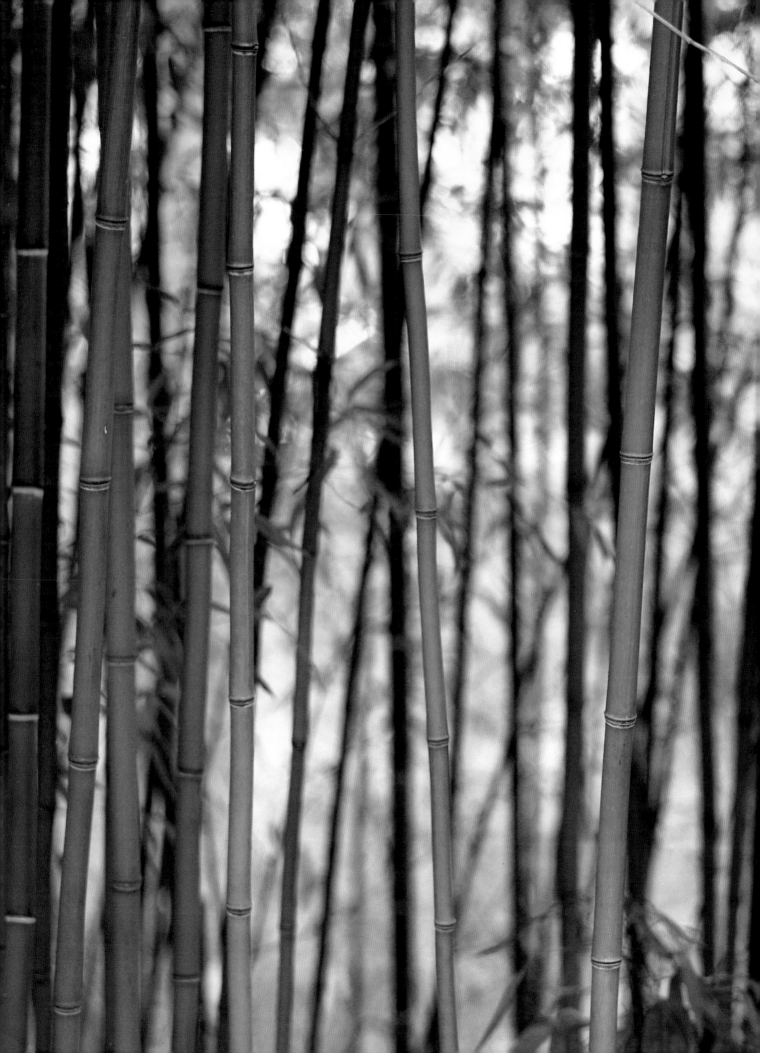

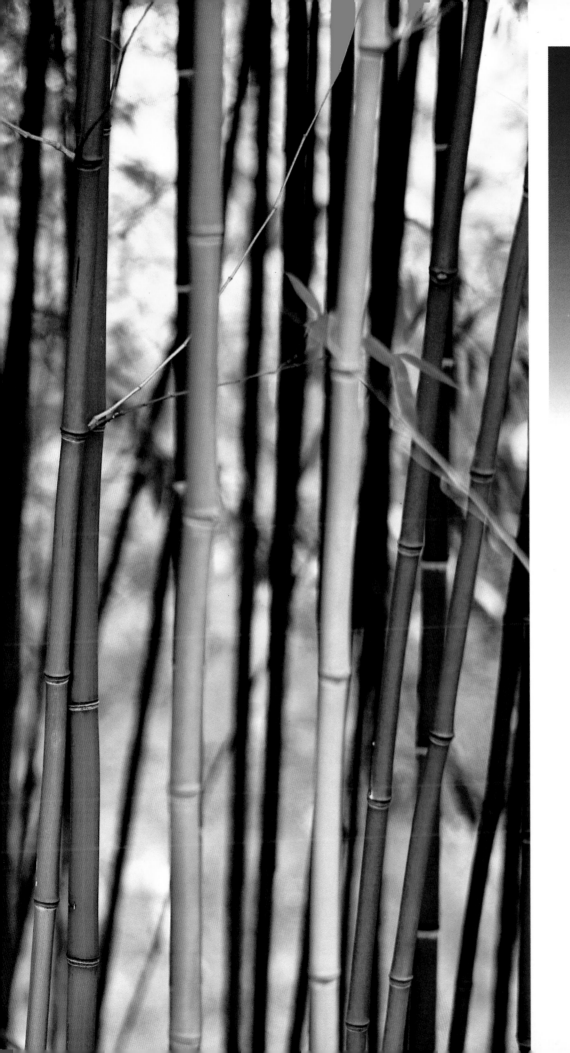

ESSENTIAL
BAMBOO

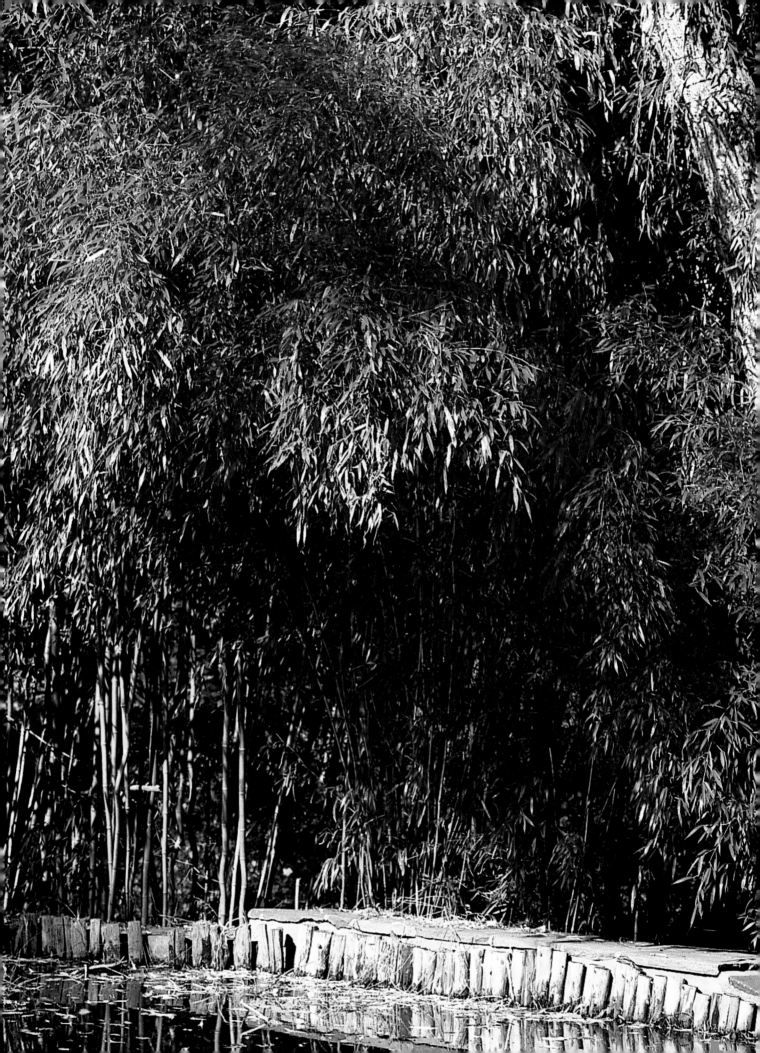

RARE LUCK IT IS INDEED

TO BE BORN IN HUMAN FORM.

AS SUPPLE BAMBOO GROWS,

STRAIGHT IS THE ROAD

THAT ALL SHOULD FOLLOW.

ISSA

Listen to the bamboo. Hear it tell of an ancient people who believed in the interconnectedness of all things. Discover its legendary 1,400 uses. Find the power to be as bamboo, able to bend but not break, to yield yet survive.

Called *take* in Japanese, bamboo has played a vital role in the hearts, minds, and lives of people for thousands of years. It is interwoven into the philosophies, beliefs, everyday life, art, legends, and superstitions of Japan and throughout Asia. Though ubiquitous, bamboo can never be taken for granted.

Strong yet flexible, bamboo's beauty of form, motion, and sound as it rustles in the landscape is rivaled by its adaptability to a fabled 1,400 uses.

Actually, there are many bamboos, more than a hundred genera and over a thousand species; the exact number is the subject of much taxonomic debate. The conflict arises because plants are identified by their flowers, and many bamboos bloom only every thirty years, with some waiting over a hundred years for the reproductive urge. This rarity of flowering has led some to interpret the blooming of bamboo as a prophecy of calamity. This may be due, in part, to the fact that entire bamboo forests sometimes die after blooming. The blooming habit is also unusual in that stands of the same species of bamboo located in disparate parts of the world, will frequently all bloom at the same time, regardless of climate or growing conditions. Just to complicate matters, some bamboos bloom frequently and do not die afterwards.

What are the aspects of bamboo's physiology that distinguish it, making it such an integral part of Asian cultures?

The most apparent characteristic is the stem, or stalk, correctly known as a *culm*. Depending on the species and growing conditions, bamboo culms range in size from less than eighteen inches (45 cm) to over a hundred feet (30 m) tall and from a fraction of an inch (centimeter) to a foot (30 cm) or more across. Most are woody and stiffly erect, but some bend gracefully while others arch, zigzag, or twine. The woody bamboos are unusual in that, unlike trees and shrubs, the emerging culm is the same diameter that it will always be, even when many feet (meters) tall. Although a culm may live for a decade, it will reach its mature height in a single season, never growing taller. Green is the predominant color, but some bamboos have yellow, brown, black, purplish, spotted, or striped culms.

Bamboo culms have distinctive segments, consisting of nodes and internodes. It is the solid nodes that give the culm its significant strength, while the internodes, with just a few exceptions, are characteristically hollow. The cellulose fibers in bamboo differ from trees in that they are about ten times as long and contain both lignin and silica instead of just lignin.

As the culm emerges and grows, each internode is covered by a leafy sheath. These protect the culm and provide growth hormones. When the culm stops growing, the sheaths of many species fall off. With maturity, branches and leaves form at each node. Bamboo leaves are generally long and narrow with pointed tips. Evergreen, the leaves are the voices of the bamboo, fluttering with the barest wind, creating a magical interplay of sound and movement.

The grace of movement and form belies the tenacious growth of bamboo. Used judiciously, many bamboos can emphasize the harmony of proportion, line, and materials in Japanese architecture and ornament, as witnessed in this tea house.

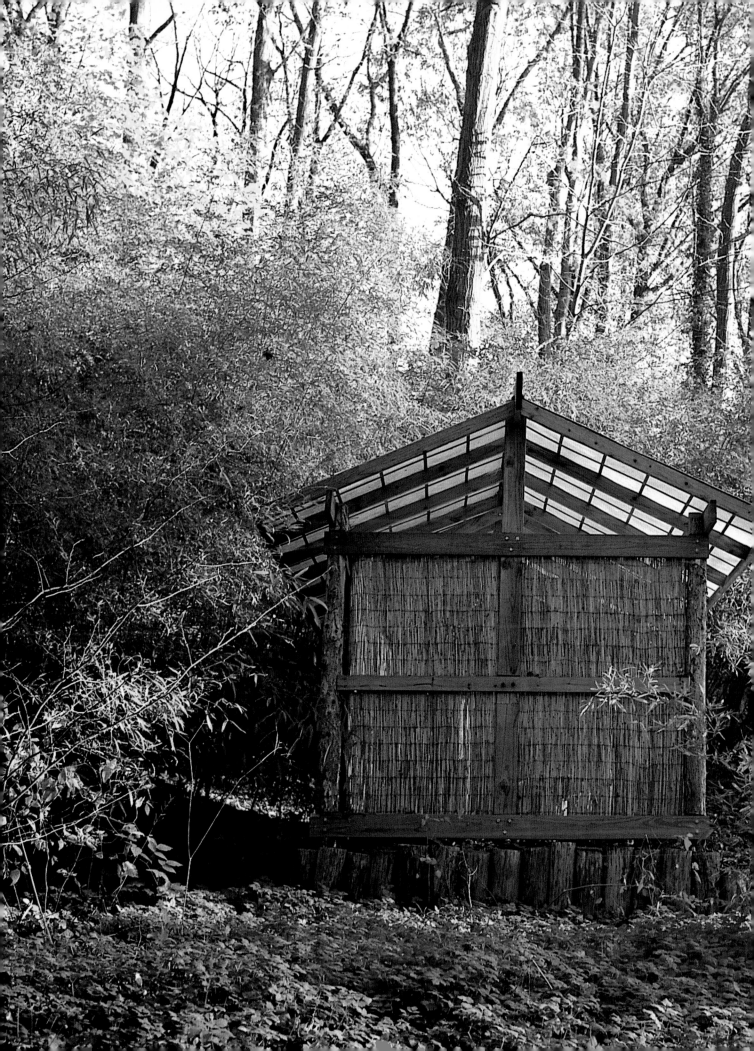

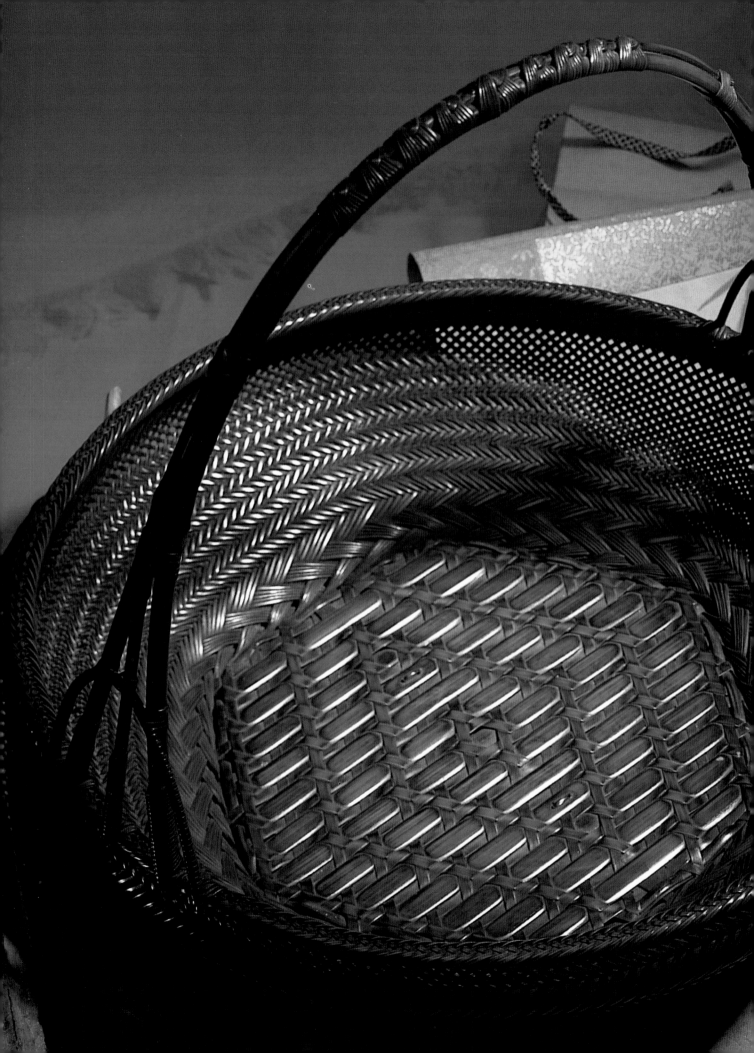

A morikago is a shallow,
open basket for displaying
fruit during the sencha
ceremony, which uses green
leaf tea rather than the
powdered tea of the chanoyu.
Flowers may also be used
in a morikago, but what a
loss to hide the pattern inside
the base of the basket.

No other plant material
possesses the qualities of
bamboo that allow it to be
split into very thin, narrow
strips of great flexibility.

I CUT THE LILIES,

AND SIDE BY SIDE I PLACE THEM

ON TOP OF THE GRASS.

SŌKYŪ

Bamboos send up the culms from swollen underground stems called *rhizomes*. The true roots are much thinner and develop from the nodes of the rhizomes. Growing horizontally more than vertically, the rhizomes seldom penetrate deeper than three feet (90 cm). The tight mass they create at this shallow depth is such that, in Japan, people consider bamboo groves safe during earthquakes since the soil supposedly cannot be broken apart there. Basically, there are two types of rhizome growth, clump-forming and running. Care must be taken in planting the running type in gardens, as they can be quite invasive unless the new shoots are regularly cut off. Bamboos are also known for the rapidity and rapaciousness of their growth. The taller types can actually be observed growing, as they expand up to sixteen inches (40 cm) each day.

Bamboos used to be considered members of the Gramineae family, or grasses just like those plants in lawns and grain fields, but now they are classified separately as the Bambusoideae family. The natural geographic distribution of bamboos includes tropical, subtropical, and temperate climates, ranging from sea level to the snow line on mountain sides.

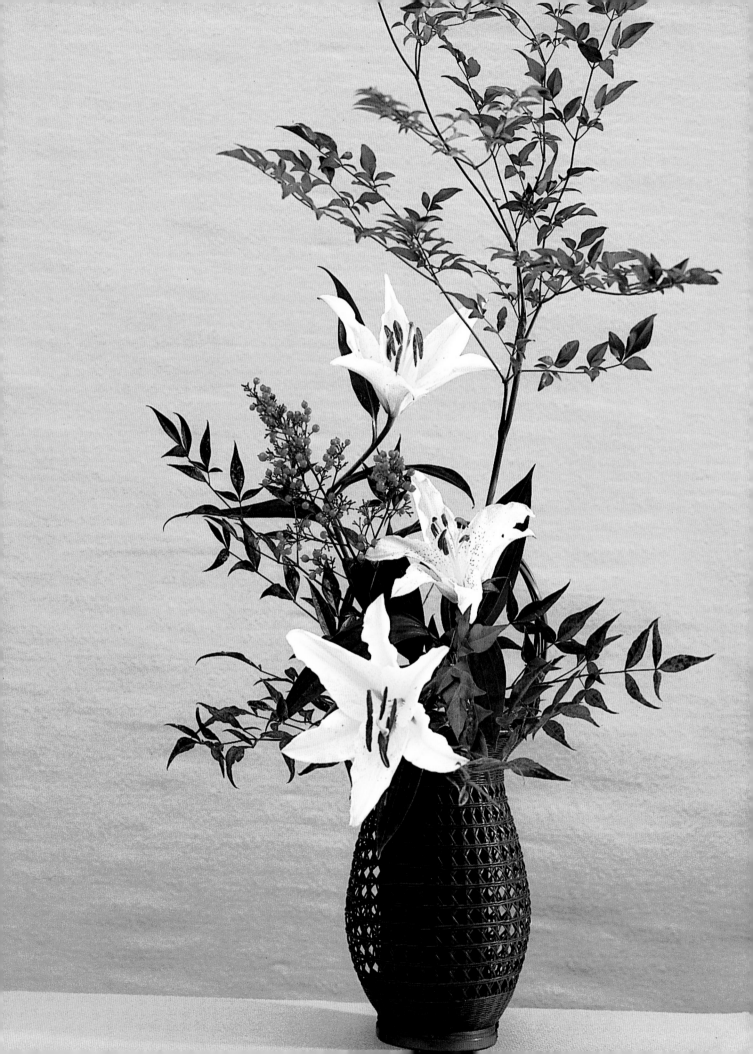

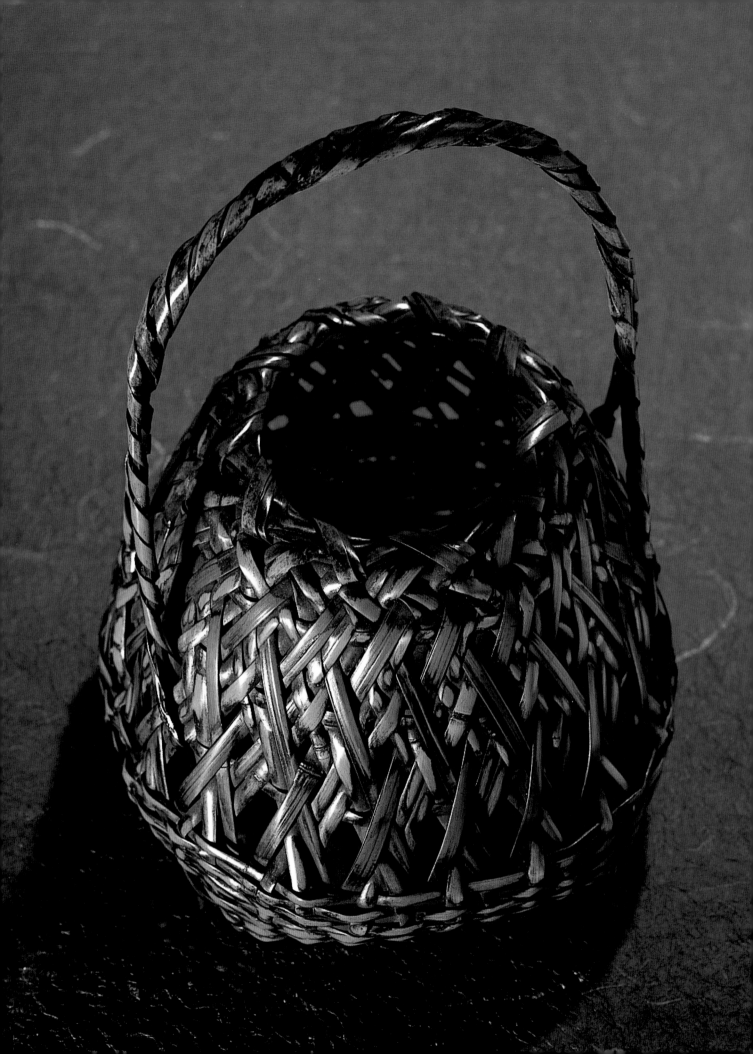

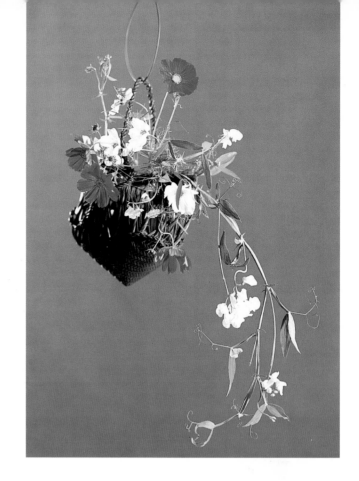

Burnished portions of soot-blackened bamboo strips enchant the eye with their duality. Only with many years of practicing and studying the traditions of the art, can a basket maker have the discipline necessary to speak with such simple eloquence.

A land rich in plants, Japan's natural landscape is filled with bamboo. Besides the wild growth, stands of bamboo are also cultivated for economic, soil preservation, and land reclamation uses. The gardens of Japan, designed to depict nature in an abstract form that will encourage meditation, utilize bamboo as a *yo*, or male element. The leaves of bamboo contrast with the needles of pines and serve as a foil for plum and cherry blossoms. Plantings of bamboo in Japanese gardens are often thinned to showcase individual culms and subtly suggest a forest. Important plants in temple gardens, bamboos, especially rare species, are prominently displayed. One such planting in Kōchi, of bamboo with golden-striped stems, has been designated a natural monument.

Malleable and lightweight but strong as steel, bamboo is an adaptable, inexpensive raw material with innumerable and diverse daily uses. As A. B. Freeman-Mitford wrote in *The Bamboo Garden* (1896), "...the Bamboo is of supreme value; indeed, it may be said that there is not a necessity, a luxury, or

a pleasure of... daily life to which it does not minister." Providing material for houses, furniture, clothes, musical instruments, paper, and medicine, bamboo is even used as scaffolding around modern urban buildings. Bamboo shoots, harvested just before they emerge from the soil, are a vitamin-rich cooking ingredient. Seeds of bamboo are harvested and cooked like rice or made into a fermented drink. Thomas Edison experimented with bamboo fibers as filiments in electrical light bulbs, and scientists have found advantageous properties of bamboo charcoal, including making improved electric batteries. Dried bamboo leaves have been patented for deodorizing fish oils. Liquid diesel fuels have been distilled from bamboo culms, and it has been discovered that the white powder produced on certain bamboos contains compounds related to female sex hormones.

As a spiritual symbol, bamboo has long been one one of the most revered of plants in Japanese culture. For those who study Zen Buddhism, the hollow culm represents the essential principle of Emptiness. In many Asian myths, the first man springs from the hollow internode. At the Japanese new year, homes are decorated with a number of plants, including bamboo, symbolizing long life and Buddha. Since the eighth century, there has been an annual festival celebrating the start of the bamboo-splitting season. Cutting a newborn child's umbilical cord with a bamboo knife ensures a happy life.

In the arts, brushes for painting and calligraphy are still made of pliant bamboo stems with animal-hair bristles. The first books in Asia were made on blocks of bamboo, and some of the earliest paper was also made of bamboo. It is in the realm of basketry, however, that bamboo plays the most strikingly dominant role. Bamboo's strength, flexibility, and versatility have provided bamboo craft artists with expressive opportunities for centuries.

Although the greatest number of bamboos are found on the southern and southeastern borders of Asia—including India, China, Korea, and Japan—they are also found in Madagascar, Africa, Central America, Chile, Argentina, and the United States.

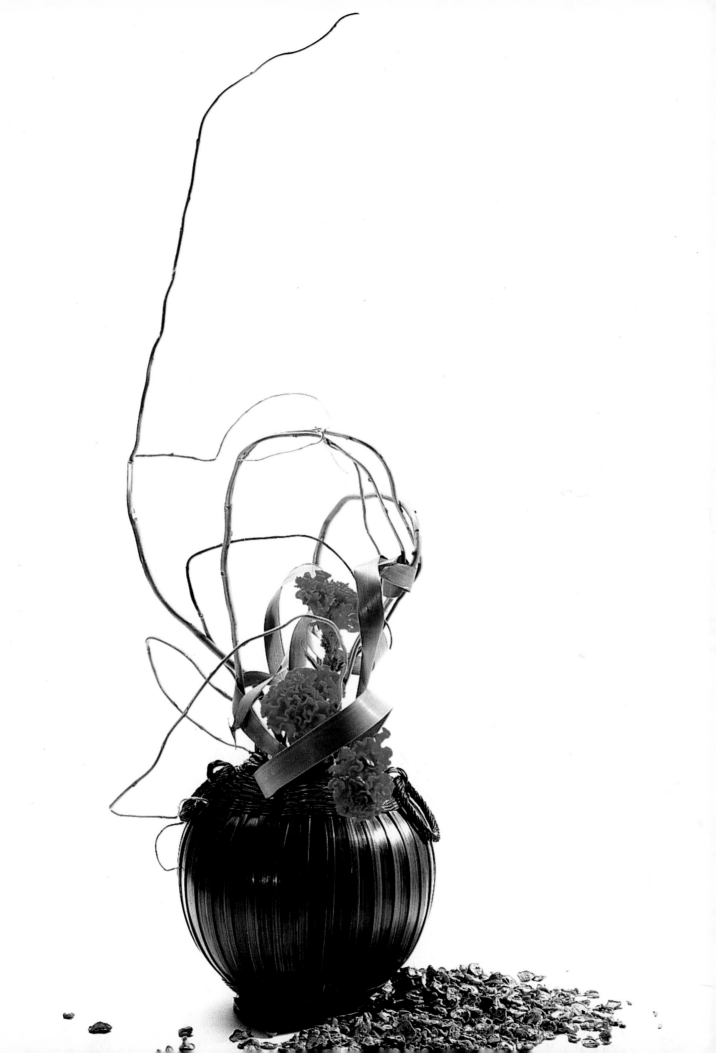

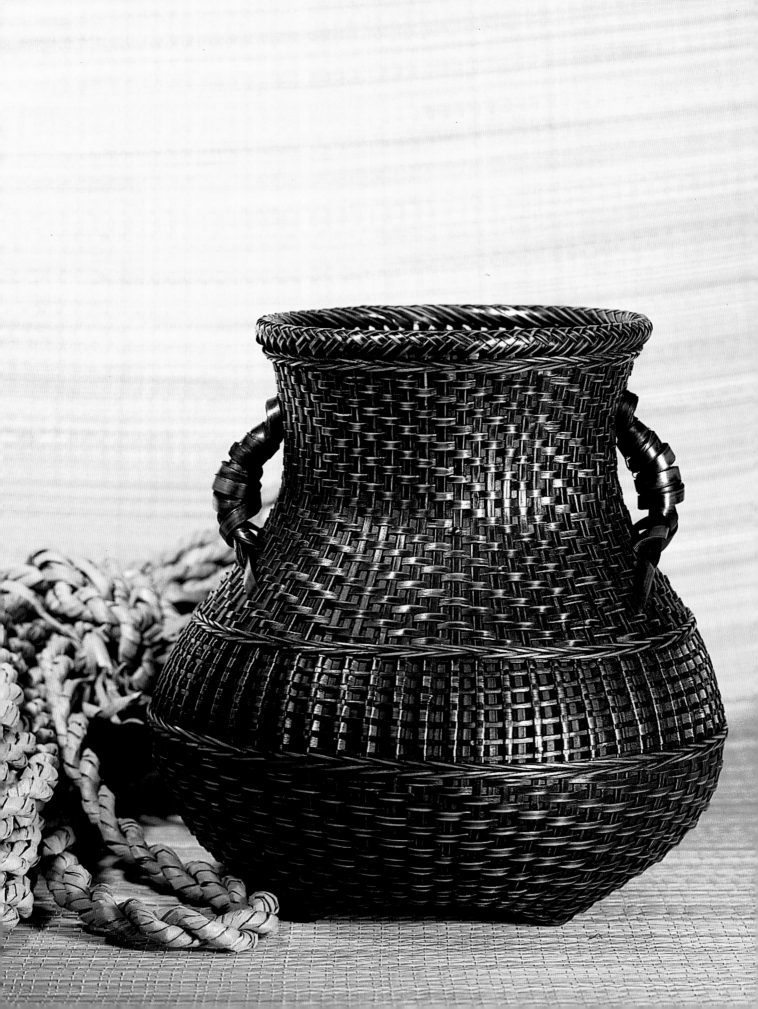

THE GARDEN IS NOW

LEFT UNSWEPT, FOR MAPLE LEAVES

FLUTTER FROM THEIR BOUGH.

HEKIGODO

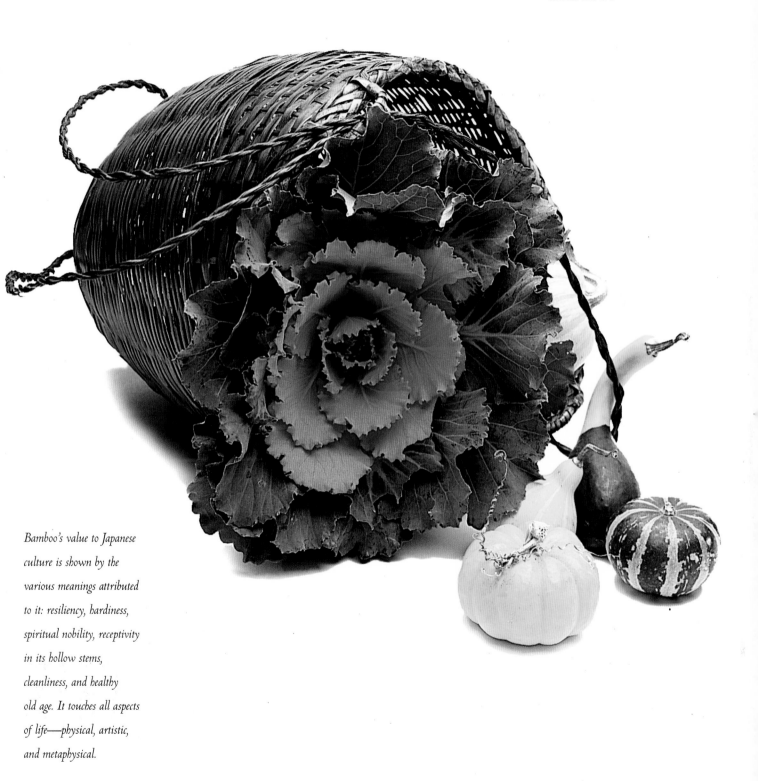

Bamboo's value to Japanese culture is shown by the various meanings attributed to it: resiliency, hardiness, spiritual nobility, receptivity in its hollow stems, cleanliness, and healthy old age. It touches all aspects of life—physical, artistic, and metaphysical.

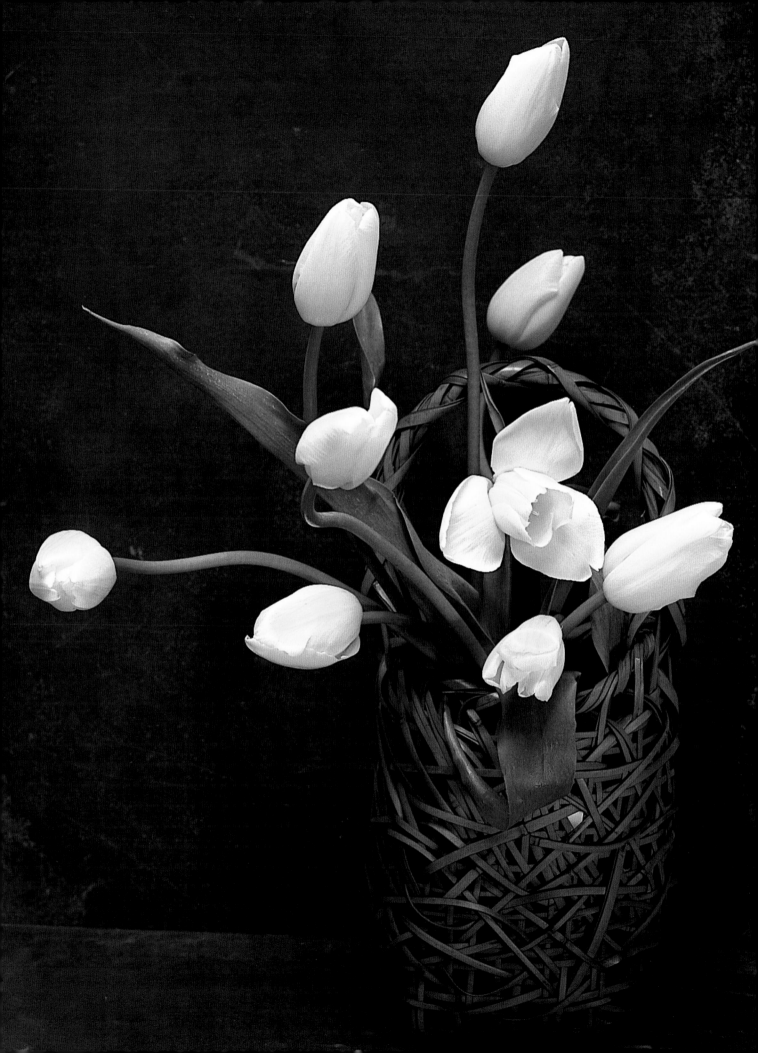

The most important species of bamboo for basket making is *Phyllostachys bambusoides*, known in Japan as *madake*. Native to China but naturalized in Japan, it is also called giant timber bamboo since it grows to more than seventy feet (21 m) tall, with culms up to six inches (15 cm) in diameter. It is valued for its substantial texture, extreme suppleness, and ability to be cut into straight strips that may be only ⅟₁₆ of an inch (1.5 mm) in width. Other species of bamboo used for basketry include: *Bambusa brealis* (*suzutake*), *Sasa kurilensis* (*nemagaridake*), *Pleioblastus simonii* (*medake*), and *Phyllostachys nigra* (*hachiku*).

For basket making, bamboo is best harvested in the fall, when insects and moisture content are at a minimum, with three- to four-year old culms having the ideal balance of solidity and flexibility. Once cut, the culms are washed to remove dirt and the powdery substance found on certain species. The culms are then dried vertically for several months in a dark, airy place.

Next, the bamboo culms go through a leaching process to remove the oils. Leached bamboo is called *sarashidake* and has a creamy yellow color and shiny surface. Leaching is essential if the bamboo is to be dyed, plus it increases strength, pliability, and resistance to insects and mildew. Traditionally, leaching is achieved by heating the culms repeatedly over a charcoal or gas fire. A cheaper method is to boil the culms in an alkaline solution, then to bleach them in the sun for several weeks. However, bamboo processed by this method tends to darken and crack with time.

Baskets with a deep, rich, red-brown color are made from *susutake*, bamboo that has been part of a traditional thatched-roof house and exposed for decades to smoke from a hearth or cooking fire. The color will vary

With just a few leaves of the same plant or one color of flowers, an ikebana arrangement confirms the saying from the oldest account of Japan that "every plant can express itself." The arrangement to the left contains tulips in a sarashidake basket.

depending on what has been used as fuel. Straw, for example, yields a lighter color than wood. Sooted bamboo baskets are valued not only for their beauty, but for the difficulty of using the less-flexible material. Attempts to artificially smoke bamboo have not been particularly successful, and as fewer and fewer traditional houses are built, baskets made from sooted bamboo will become more rare.

In the past a bamboo artist would be involved with the culms from the time of cutting, but today most purchase them, looking for quality pieces that are straight, with few knots. The tedious and time-consuming process of preparing the strips from the culms still belongs to the artisan. The first decision is whether to dye the bamboo or not. If it is to be dyed, the waxy, silica-covered surface is scraped off. Then, sections of bamboo are cut to the desired length. Next, culms are split in half, usually from the tip to the root end. Each piece is then cut successively in half until the appropriate width is reached. It is essential that the strips be uniform in width.

Four uncut bamboo culms serve as feet at the base of this basket. The culms are split further up the sides to become part of the plaiting.

A famous Japanese legend tells of a bamboo cutter who saw a light in a bamboo culm and found a tiny girl. Taken home, the girl grew to such beauty that the emperor wanted to marry her. As a moon princess, she refused him in a letter and returned to the bamboo. In grief, the emperor burned the letter, which burns to this day at the top of Mt. Fuji.

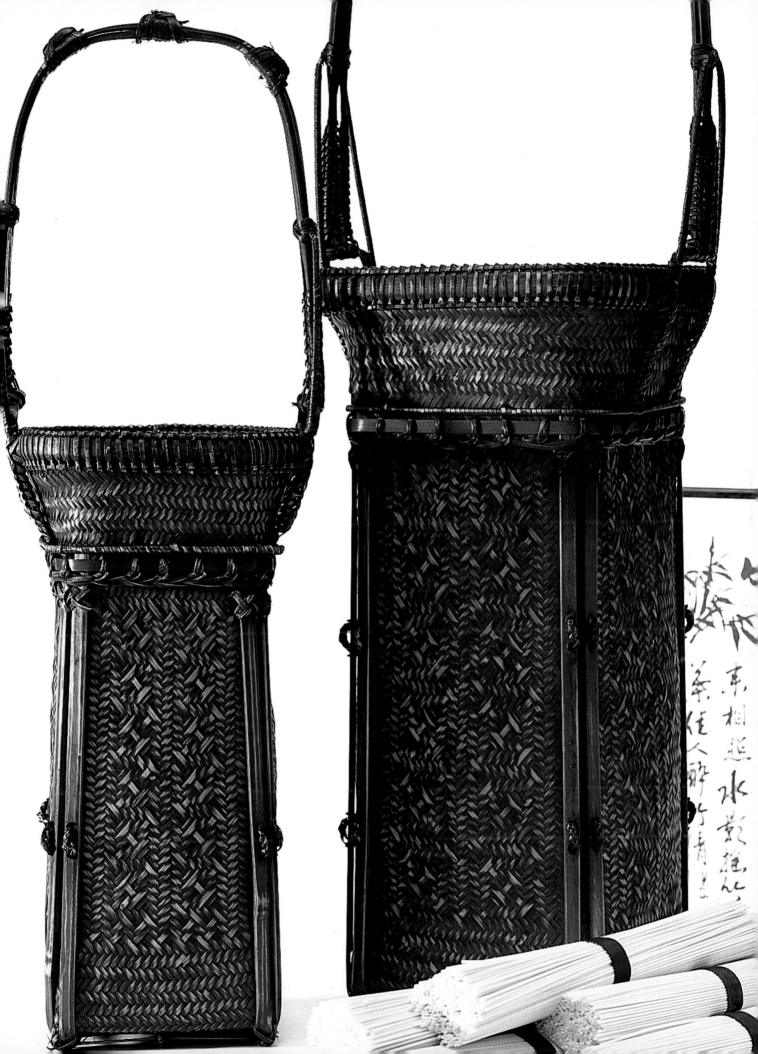

東相　水軟雉　菜佳人酔　青

*"Plaiting and wicker-work
of all kinds, from the
coarsest baskets and matting
down to the delicate filigree
with which porcelain cups
are encased—so cunningly
that it would seem as if no
fingers less deft than those of
fairies could have woven the
dainty web—are a common
and obvious use of the fibre."
—A. B. Freeman-Mitford*

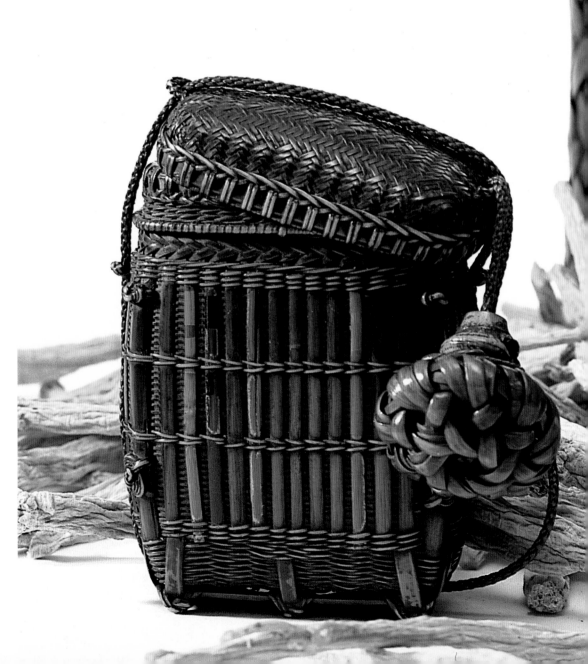

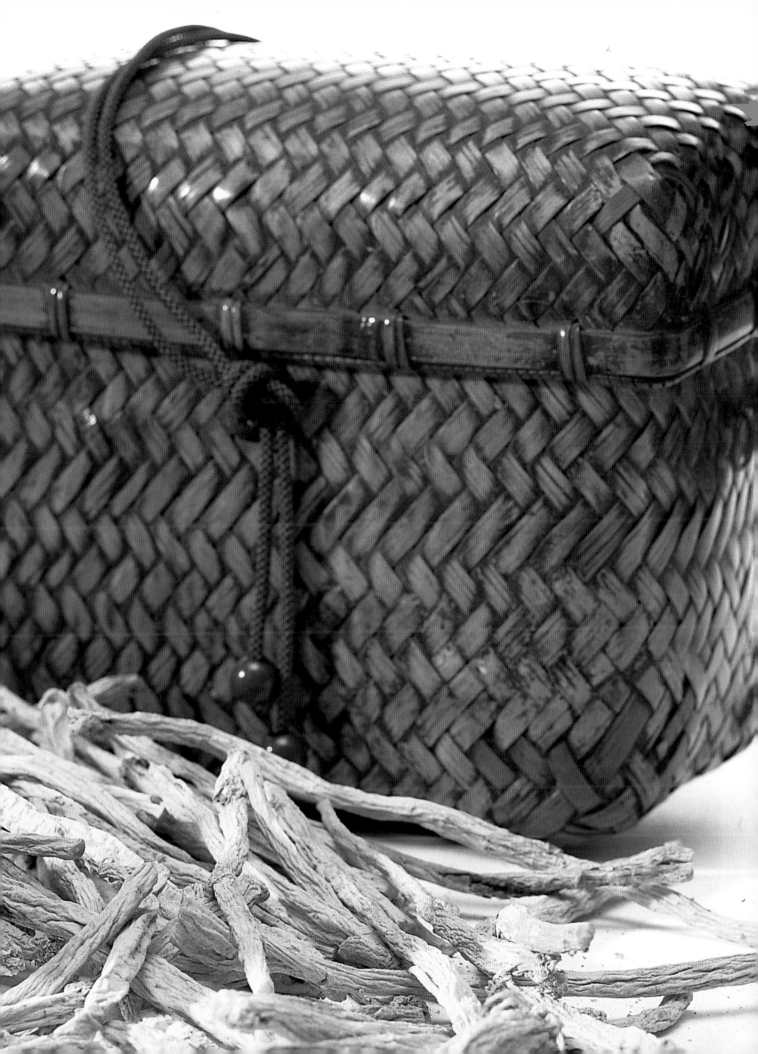

Stripping is the next step. This involves shaving off the inner and outer surfaces, plus knots, until the strips are smooth and of an even thickness. The prepared strips are called *hirihagi*. These strips are used with the shiny outer surface appearing on the outside of the basket. Sometimes the strips are split into even narrower pieces, called *masawari*, to be woven with the edge showing on the basket exterior. *Masawari* are used to decorate many of the finest flower baskets.

Finally, the strips are cut into their finished width, then dyed if desired. Basket makers use different methods of dyeing, ranging from commercial dyes to lacquers and natural plant dyes, such as plum wood.

Bamboo's toughness and durability makes maintenance of baskets simple. Avoid extremes of temperature and humidity, dust regularly, and clean crevices with a small, soft brush. If necessary, wipe with a dampened cloth. To polish, use a mixture of lemon juice and beeswax.

When contemplating a finely crafted bamboo basket, we see a beauty reflecting the artist's skill, vision, and many hours of labor. With further reflection, we can also appreciate the hundreds of years of Japanese culture and history that lay behind it. Interwoven with the bamboo strips are spiritual beliefs and a way of life that follow the path of the Oneness in all things.

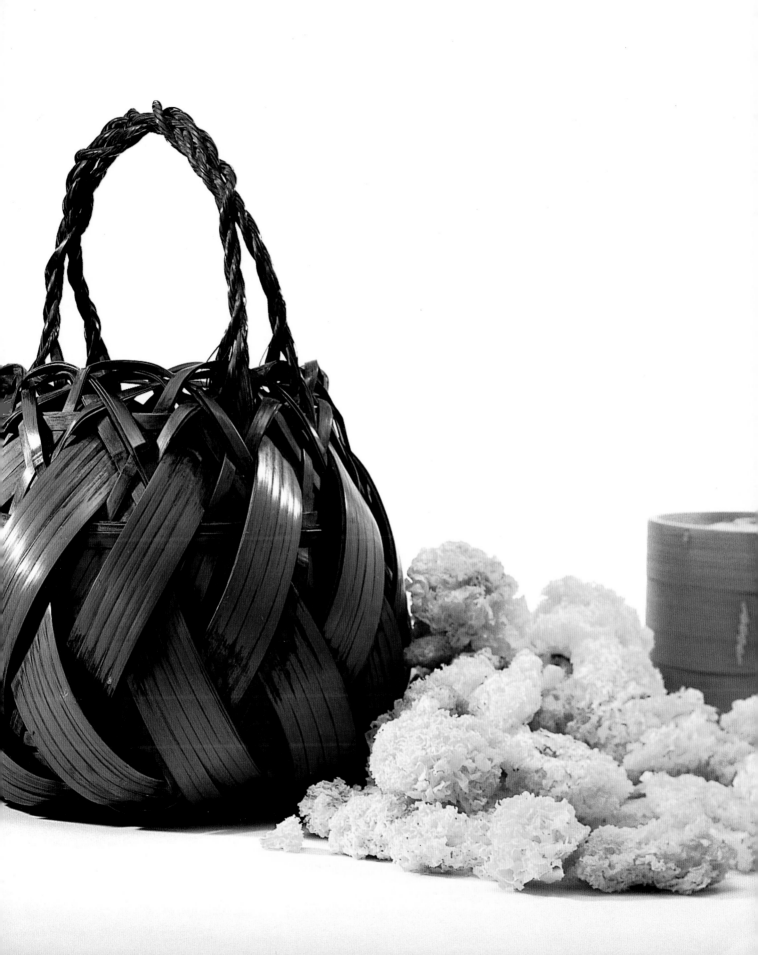

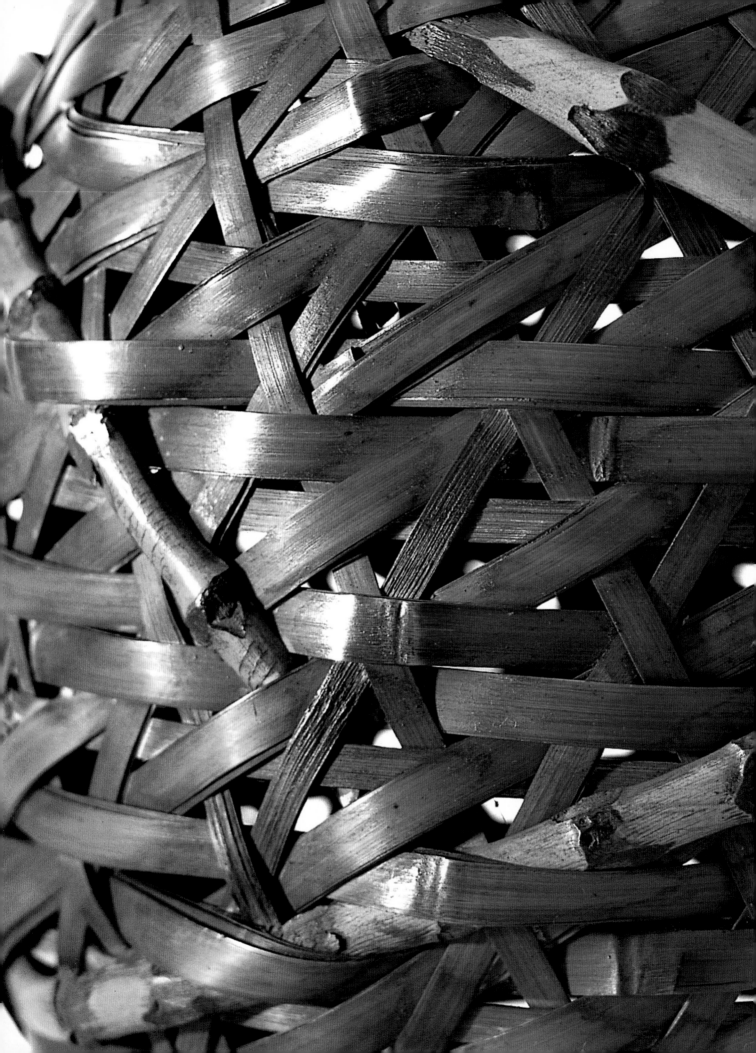

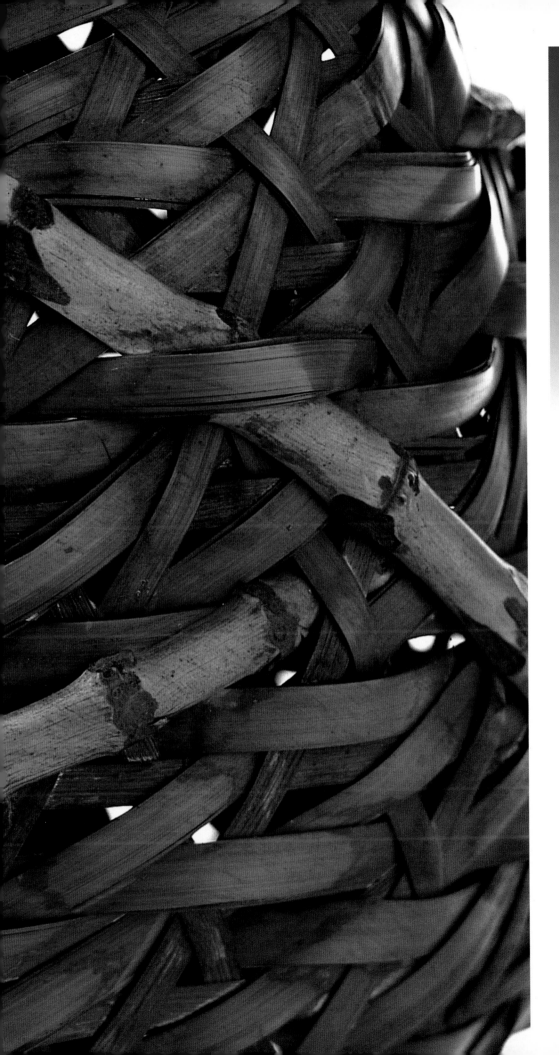

THE
UTILITY
AND
BEAUTY
OF BAMBOO
BASKETS

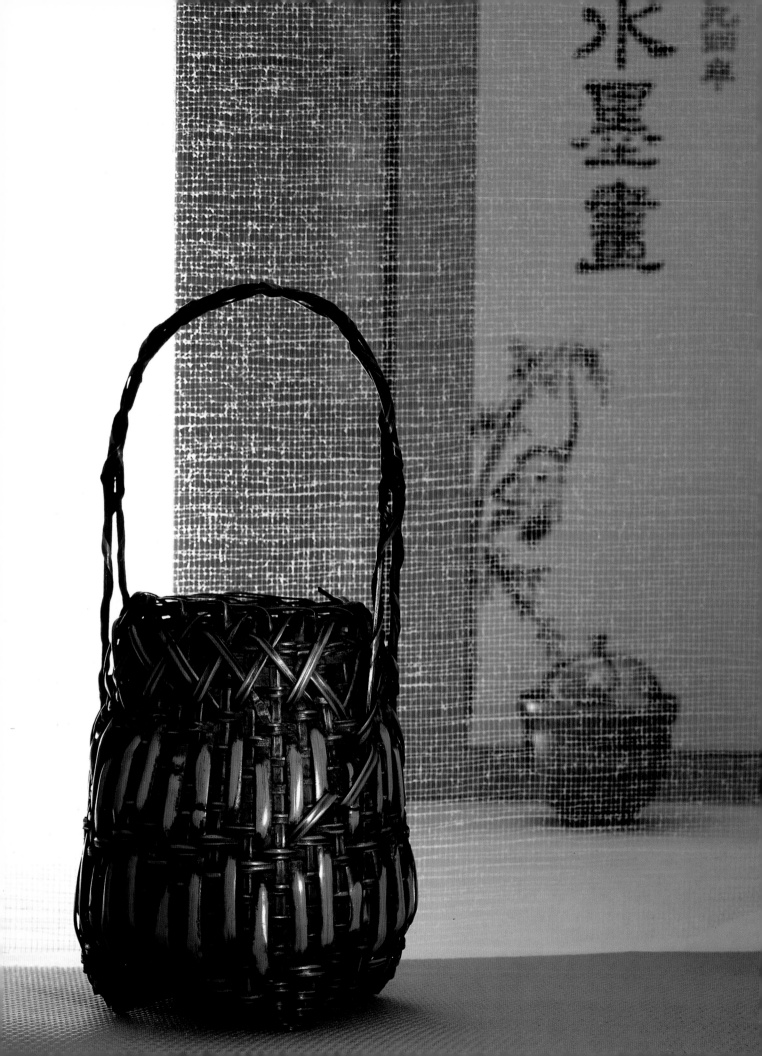

Distilled to its essence, a basket is no more than a weaving of stiff vertical and horizontal strips. Limiting those strands to a single material would seem to restrict the outcome even more. Yet, just as there are an infinite number of paths to enlightenment, so too are there innumerable ways of interlacing bamboo strips into a basket. A unique handmade basket arises from the interplay of basic techniques in the mind and heart of the bamboo craft artist. The lithe strips of bamboo are worked as they have been for hundreds of years. Drawing upon a rich cultural and spiritual heritage, the artisan honors both the past and the future to create an object that is both aesthetic and functional.

Unlike many of the other Japanese arts, there is no formal classification system for bamboo flower baskets, or *hanakago*. Rather, they are discussed in terms of their shape, historical period or reference, region of origin, formality, and method of construction.

Parallel arts, for use in the tokonoma, scroll paintings and bamboo flower baskets have yielded a wealth of beauty over time.

Japanese flower baskets have their origins in Chinese baskets that were brought into Japan during the Muromachi period (*circa* 1392-1568). Called *karamono*, or "Chinese object" baskets, these were complex and intricate weavings of very thin, narrow bamboo strips decorated with elaborate knots and wrappings. Usually symmetrical, they often had handles and rattan around the rim. Japanese basket makers first replicated the *karamono* baskets and then integrated the new techniques into their own style.

Some of the more traditional shapes were derived from brass or celadon vases and from everyday objects like boats, gourds, and turnips. Other shapes include tall and slender baskets in either square or cylindrical forms and shorter types that can be square, round, or hexagonal. Special features include high bases, handles, or bamboo stems at the corners.

Twisted tree roots used as handles and decorations give a lively contrast of textures, both to the spherical basket's rhythmic tomokumimono plaiting and to the irregular midare plaiting of the traditional gourd shape.

During the time of the great tea master Sen no Rikyū, a major change occurred in bamboo baskets. Because Rikyū strove for a simple, serene, and humble aesthetic that reflected the spiritual aspects of nature, his choice of a container for the flowers during the *chanoyu* was often an everyday bamboo utensil, such as a fish basket, hatchet sheath, or length of bamboo stem. From this practice, baskets called *wagumi* evolved with a gentle, soothing, rustic quality. They were frequently made with wide bamboo strips, in asymmetrical shapes, and with deliberate deviations in construction. In form, *wagumi* seem as if they have arisen intuitively.

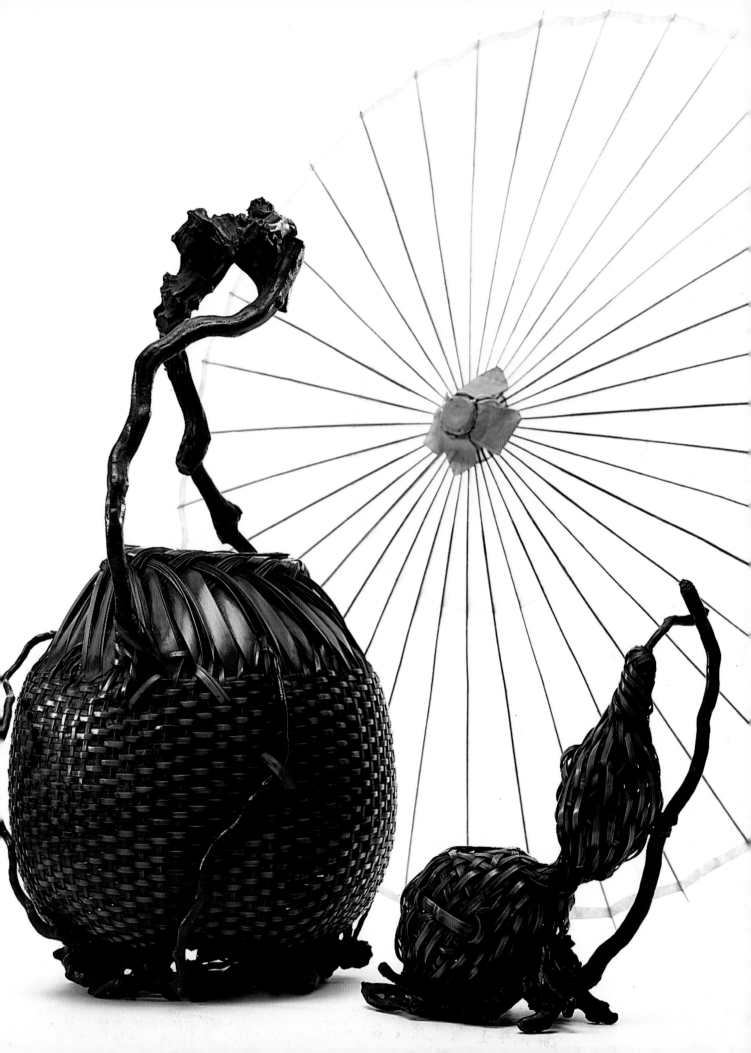

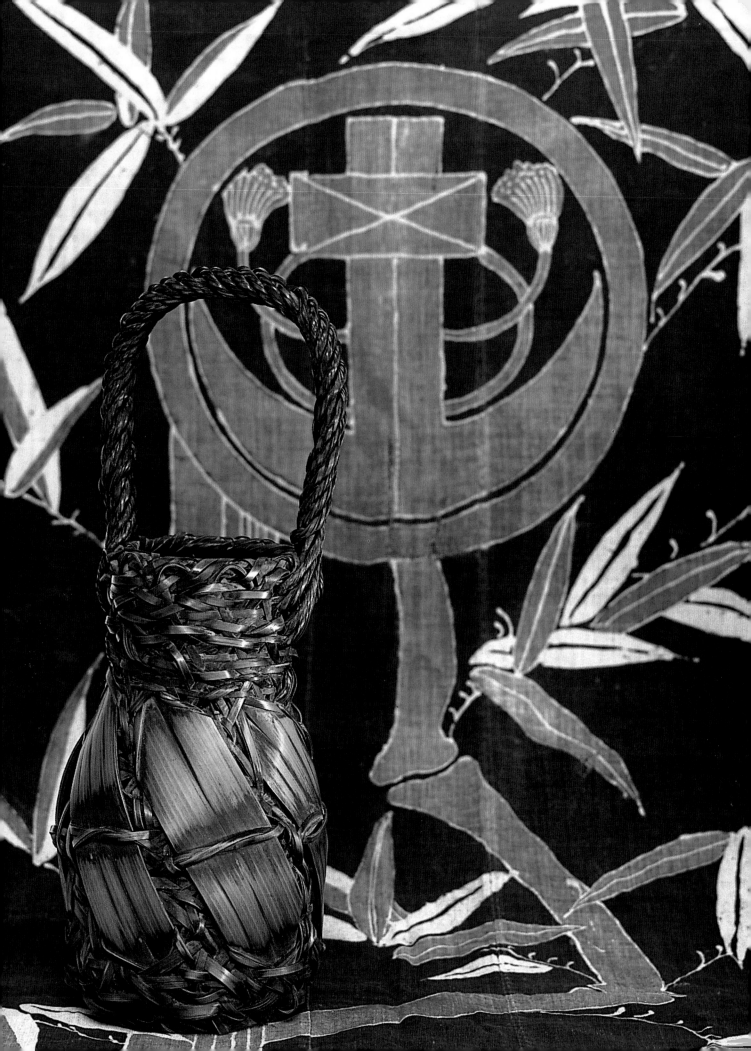

During the Edo period (*circa* 1615-1868), when Japan was closed to trade with all countries except Holland and China, imported bamboo baskets once again came into vogue. These baskets were an important part of a new style of tea ceremony, called *senchadō,* the way of *sencha* or green-leaf tea. Although *senchadō* never surpassed *chanoyu* in popularity, it did have a profound effect on Japanese culture, championed as it was by artists, poets, and intellectuals given to new ways of expressing themselves. The *sencha* ceremony was instilled with an openness and spirituality and especially honored the symbolism of bamboo. Besides a return to elegance, symmetry, and construction with thin strips of bamboo, basket makers tried a number of imaginative and original techniques. The influence of this period is still felt in basket making and the tea ceremony today.

Providing a study in contrasts, this basket utilizes the insertion of wide strips of bamboo, a style originally from the Kyūshū region of Japan, and dark, smoke-stained bamboo, susutake, which is taken from the ceiling of a traditional thatched roof house with an open fire.

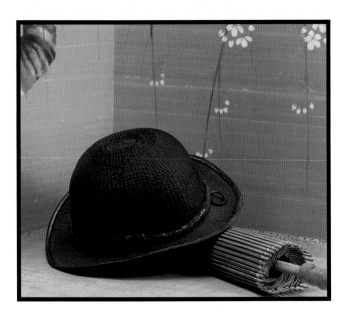

*This rare rattan hat
(circa 1850-1875) is
signed "Shōkōsai."*

It is at this time that basket makers began to sign their work. One of the
first to do so consistently was Hayakawa Shōkōsai I (1815-1897). This was
an important development which signified that basket makers were regarding
themselves as artists, not just craftsmen copying Chinese baskets. The signature
is usually found on one of the strips that reinforce the bottom of the basket or
carved into a spoke or strip woven specifically for it.

Another significant change in basket making occured when Japan opened
itself to international trade during the Meiji period (1868-1912). Baskets were
displayed at exhibitions in Japan and abroad, and the interest in them greatly
stimulated production. The increased popularity of flower arranging among
middle-class women also augmented demand for bamboo baskets, as did the
continued importance of the tea ceremony in Japanese life.

In the twentieth century, basket making has become a creative
discipline that transcends the limitations of a craft while still demanding
impeccable technique. Instead of being referred to by the traditional term of
kagoshi, or basket makers, practitioners are now called *takekōgeika*, or bamboo craft
artists. Although still requested to use their superlative skill to copy older works

*Over ten years of training
and discipline are coupled
with the creative spirit to
bring beauty and function
together in a basket. Signing
of work, a practice begun
in the nineteenth century,
showed that basket makers
considered themselves artists
and not just craftsmen
copying Chinese models.*

66

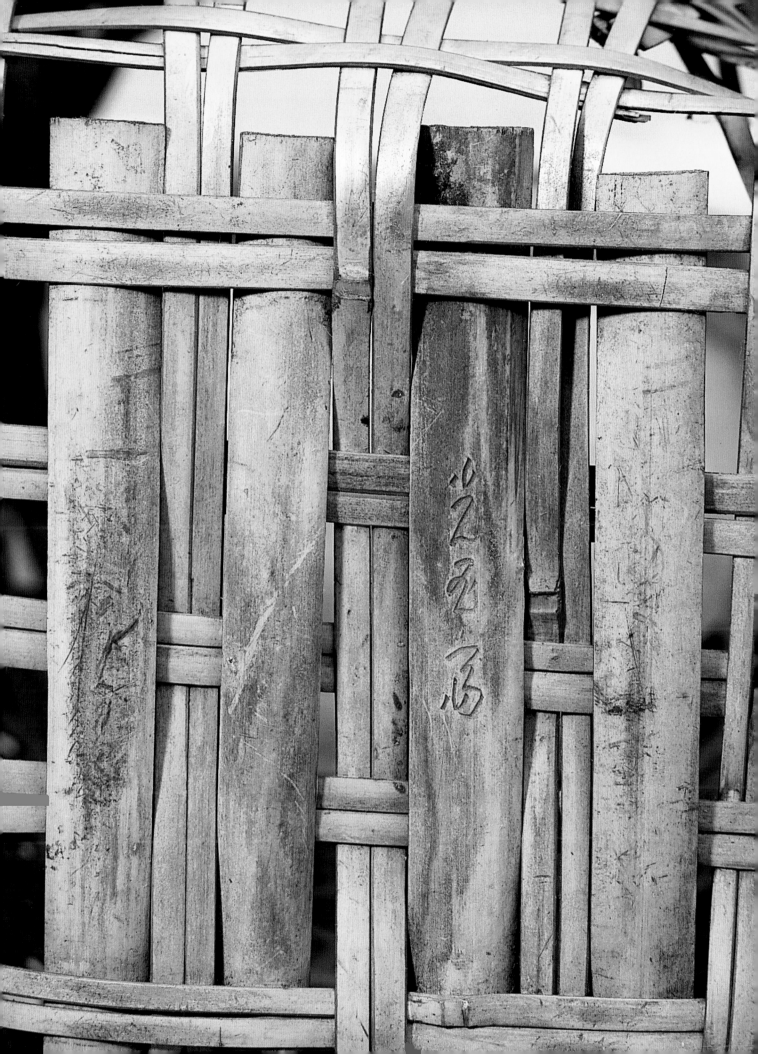

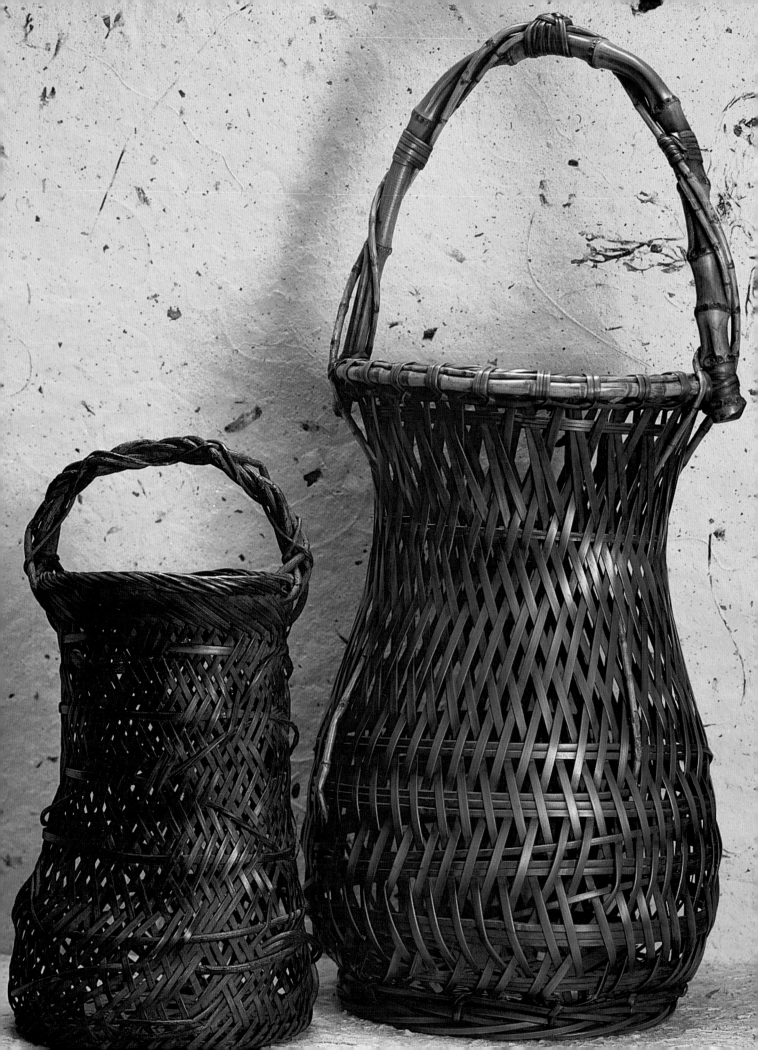

from centuries past, bamboo craft artists also have the opportunity to reach for the highest of artistic goals through their own original work.

Today, regional differences among Japanese bamboo artists are not as significant as in the past, but they do still exist. Kyoto and Nara, in the Kansai region, were the seats of some of the greatest periods of art and culture in Japan.

Baskets of simple weave or deliberate asymmetry are the outgrowth of the concepts of wabi, appreciation of the commonplace, espoused by the tea master Sen no Rikyū in the sixteenth century. To be free of worldly goods and content with the contemplation of nature was his way of life.

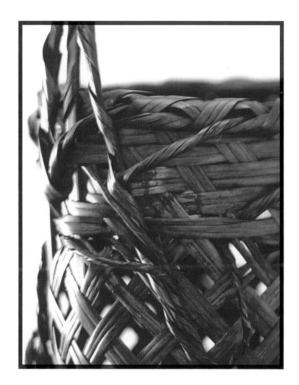

This heritage of refined elegance coupled with the popularity of the *sencha* ceremony and *karamono* baskets, has meant that baskets from these areas tend to have more intricate and delicate patterns made of very fine strips of bamboo. Even the more rustic *wagumi* baskets are affected by this influence.

Because of the outstanding characteristics of the local bamboo, the Kyūshū region has a long heritage of *kōkyū hanakago*, or high-quality flower baskets. The health resort of Beppu, in Kyūshū, drew basket makers from various regions, allowing a mixture of influences that melded into a distinctive new style. Of particular note is the use of short bamboo strips inserted into the

body of the basket to create either straight vertical lines or a herringbone pattern. The landscape of Kyūshū has also inspired basket makers there to create potent works of vigorous spirit.

One of the great twentieth-century basket makers was Iizuka Rōkansai (1880-1958), who lived in the Kantō region, which includes Tokyo. His radical methods and innovative forms encouraged experimentation around him. Rōkansai chose to classify baskets in terms of their formality. Borrowing from

The pattern yahazuzashi, after yahazu, the tail of an arrow, is created by inserting short, wide strips of bamboo into the basket body. The simplicity and symmetry of the pattern is invigorated by the twisted-root handle and the narrow, pedestal-like base.

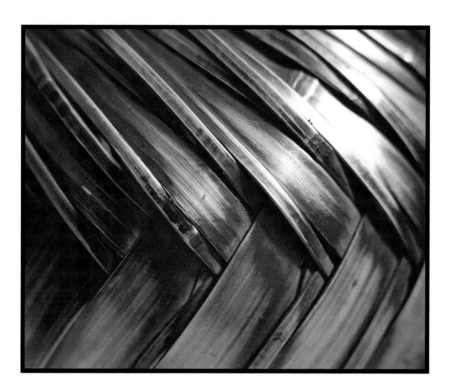

the Japanese arts of calligraphy and flower arranging, he used the traditional categories of *shin, gyō,* and *sō* to distinguish basket types. *Shin* baskets are very formal with intricate patterns. *Gyō* baskets are still symmetrical but are less elaborate. *Sō* baskets use wider bamboo strips in coarse weaves and aberrant shapes.

We tend to refer to baskets as "woven," but the Japanese make a distinction between the technique required to weave fabric and that used to create bamboo baskets. In Japanese, the word *ami* refers to plaiting, twining,

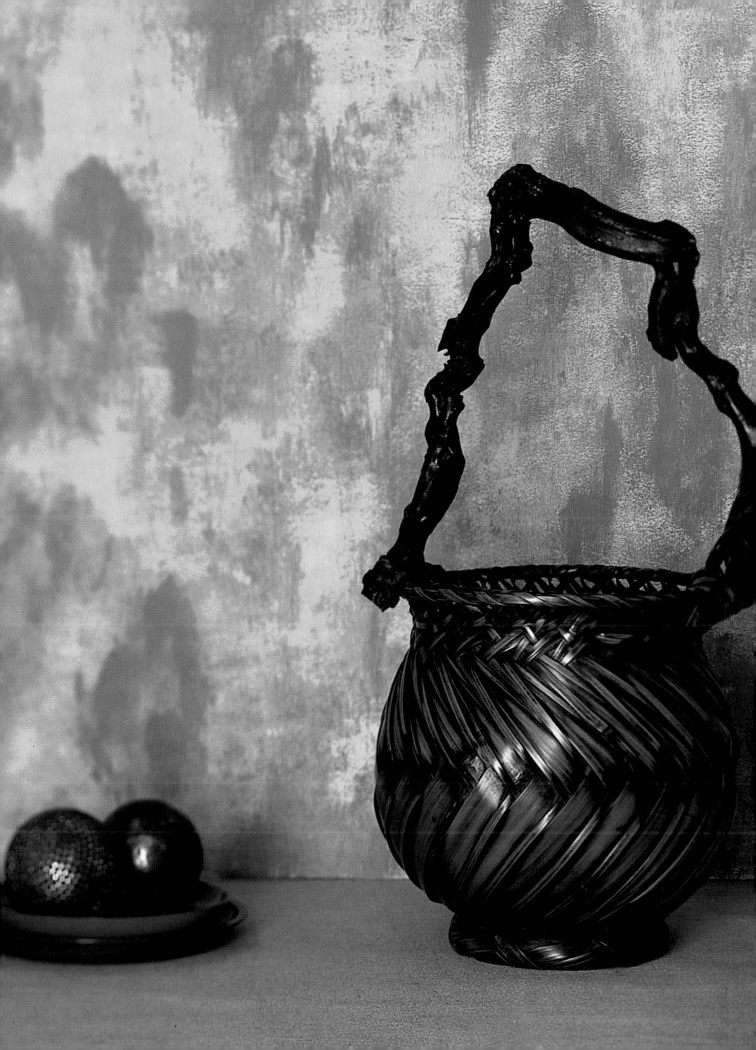

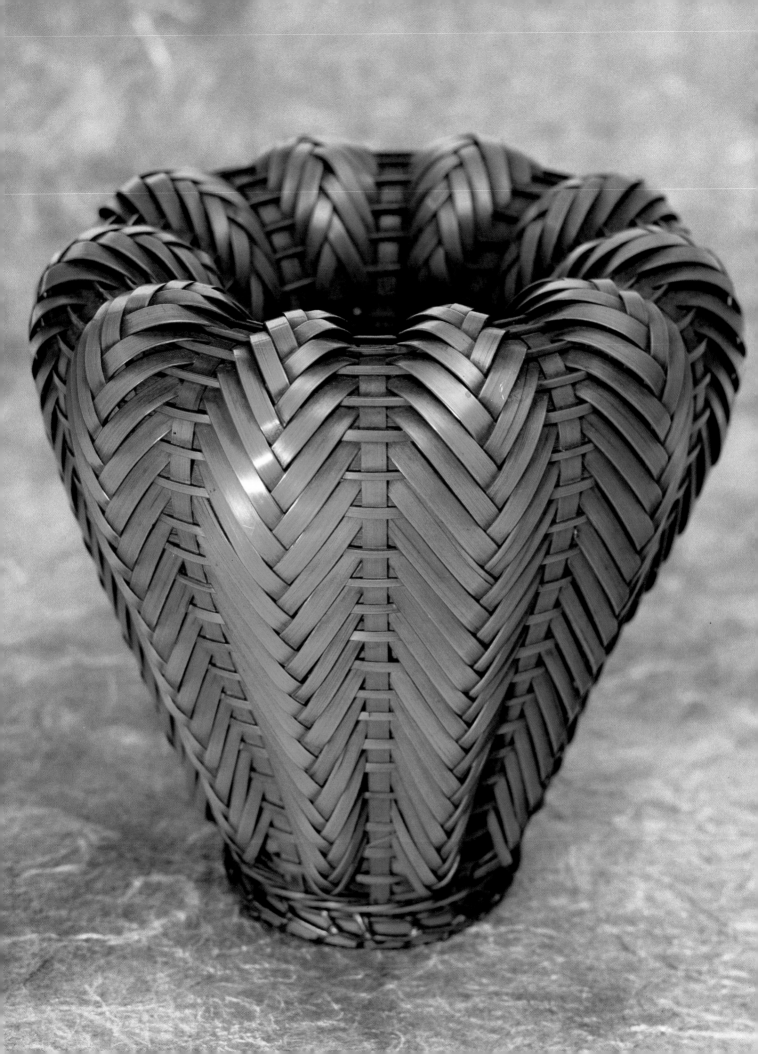

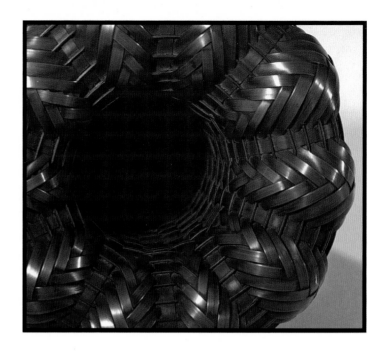

netting, matting, braiding, twisting, interlacing, even knitting and crocheting and the word is used in connection with making bamboo baskets. The actual techniques used by Japanese basket makers involve a great number of different methods. For centuries the names for these varied from region to region, but in the 1960s they were standardized. Today any basket can be divided into four basic parts: the *bottom, base zone, body,* and *rim,* which sometimes includes a handle.

Almost every basket begins at the bottom, usually with one of five methods. These include four-mesh or square plaiting, *yotsume-ami*; six-mesh or hexagonal plaiting, *mutsume-ami*; and eight-mesh or octagonal plaiting, *yatsume-ami.* The other two methods are chrysanthemum plaiting, *kiku-ami,* and twill plaiting, *ajiro-ami.*

Both square and hexagonal plaiting are such open weaves that reinforcing strips must be inserted to strengthen the bottom of the basket. This is occasionally necessary with other plaits as well. Thick and wide, these reinforcing strips are called *haritake.* On baskets with either a square or hexagonal bottom, the pieces are inserted parallel to one another. This is called a raft

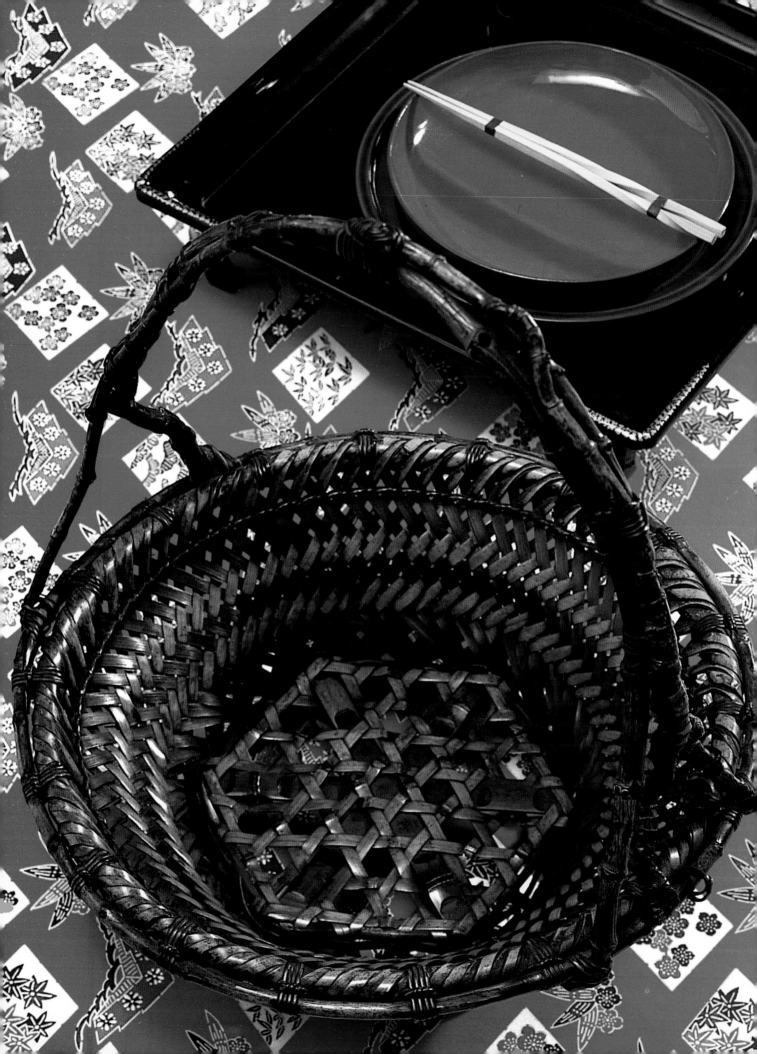

bottom, or *ikadazoko*. With a square bottom, the pieces may also be crisscrossed, either diagonally or with the square. For a hexagonal bottom, three pieces may also be placed diagonally or in a triangle.

Structurally, the most crucial area in making a basket is the base zone. It is here that the maker must bend the bamboo strips and execute the transition to the basket's body. To increase the flexibility of the strips, they are moistened or warmed over low heat and slowly bent to the desired angle. Usually, the strips

Far left: Hexagonal or six-mesh plaiting, mutsume-ami, forms the base of this fruit basket. Sooted bamboo gives the dark color contrast in the body's twill plaiting.
Near left: Rattan wrapping, maki, is one of many different ways to accent a basket handle.

angled upward from the bottom become the warp, or vertical, strips of the basket, with the horizontal strips, or weft, added separately. The base zone is sometimes reinforced by using a plaiting method called twining or by using weft made of square-cut bamboo strips.

With the body of the basket comes unlimited possibilities of shape and "weave," by using different combinations and degrees of tightness as well as

choosing to make the basket single- or double-walled. The double wall may be chosen for aesthetics or to provide extra sturdiness.

Square plaiting is the most basic form and, as such, is most often used for utility baskets. The lozenge pattern, using double strips of bamboo in a grid pattern, is more often applied to flower baskets. By far the most adaptable plaiting is hexagonal. Many patterns have developed using it as their basis.

Near right: Knots, musubi, of rattan serve to decorate, attach, conceal, or protect. Far right: A rope-like wrapped rattan handle gives warmth to the formality of the hexagonal-plaited base and wide rim of an open, shallow fruit basket.

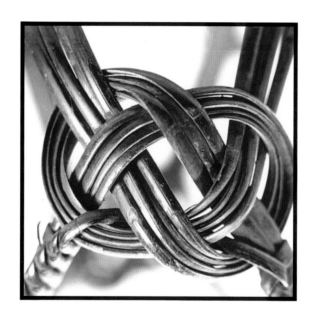

Wrapping the bamboo strips with other materials is one variation. For another, *asa-no-ha* or hemp leaf, additional bamboo strips, one horizontal and two diagonal, are interwoven.

Among the more complex variations are those using twill plaiting. At its simplest, twill plaiting involves passing one bamboo strip over either two or three other strips.

Another way to vary the design, called *mawashimono*, uses either warps and wefts of different widths or two warps to a single weft. In the variation called mat plaiting, or *gozame-ami*, the weft passes over or under the warp, alternating with each round. This requires an uneven number of warp strips, so

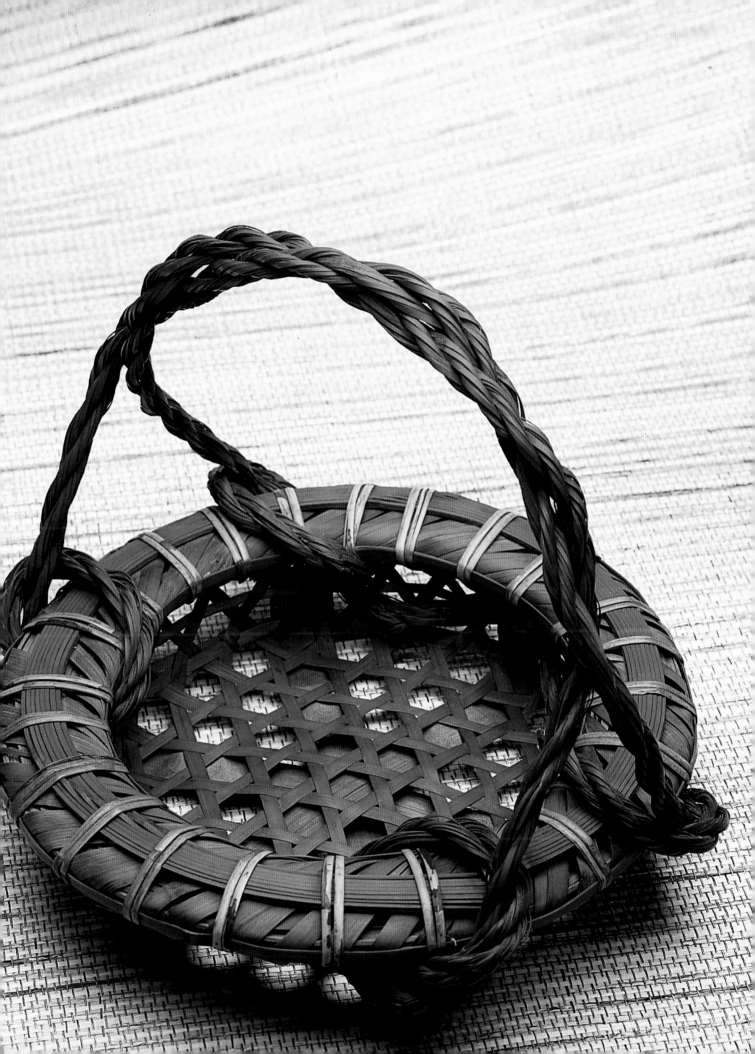

FLOWERS OFFERED TO THE BUDDHA

COME FLOATING

DOWN THE WINTER RIVER.

BUSON

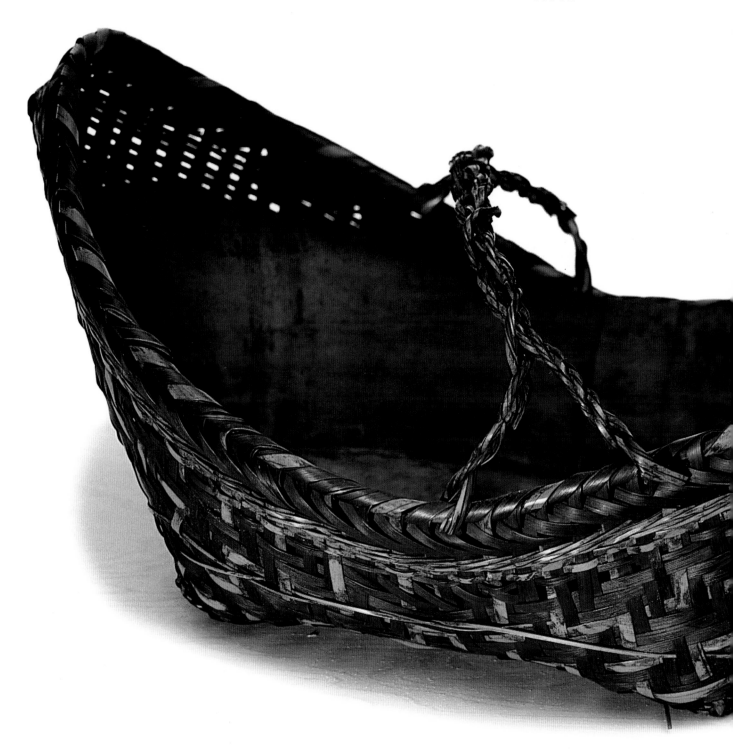

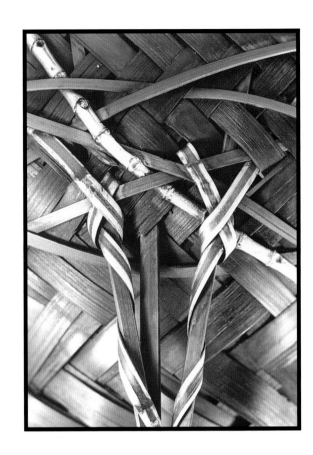

*Left: A traditional basket
shape is that of a boat, as
in this twill-plaited version.
Like many of the early
decorative bamboo baskets
of Japan, this style
was inspired by baskets
brought from China.
Above: Although formal
in origin, wrapping may
also be casual.*

either an extra is inserted or one strip is split. Producing very substantial, straightforward, and robust work, mat plaiting is often used for both utility and flower baskets. Another variation, called twining or *nawa-ami*, has two or more wefts interwoven with the warps and alternating above and below one another.

When strips of bamboo are randomly plaited and inserted into the body of the basket, the technique is called irregular plaiting, or *midare*. Hexagonal plaiting is usually used for the base. More than any other form, irregular plaiting challenges the bamboo artist. The apparent randomness belies the skill involved to create a *midare* that has balance and elegance.

The body of a basket may also be varied by using inserts, or *sashi*. If the wide bamboo strips are vertical, the pattern is called *tatezashi*. A pattern resembling herringbone is called *yahazuzashi*, after *yahazu*, the tail of an arrow. This pattern may be either vertical or horizontal. Strips may also be inserted diagonally, giving an appearance somewhat like that of irregular plaiting.

Utilizing bamboo strips freely plaited and inserted into the body, midare is a popular style for flower baskets. Most often made using strips of uneven width, a textural refinement is obtained by using even widths, a technique called tomokumimono.

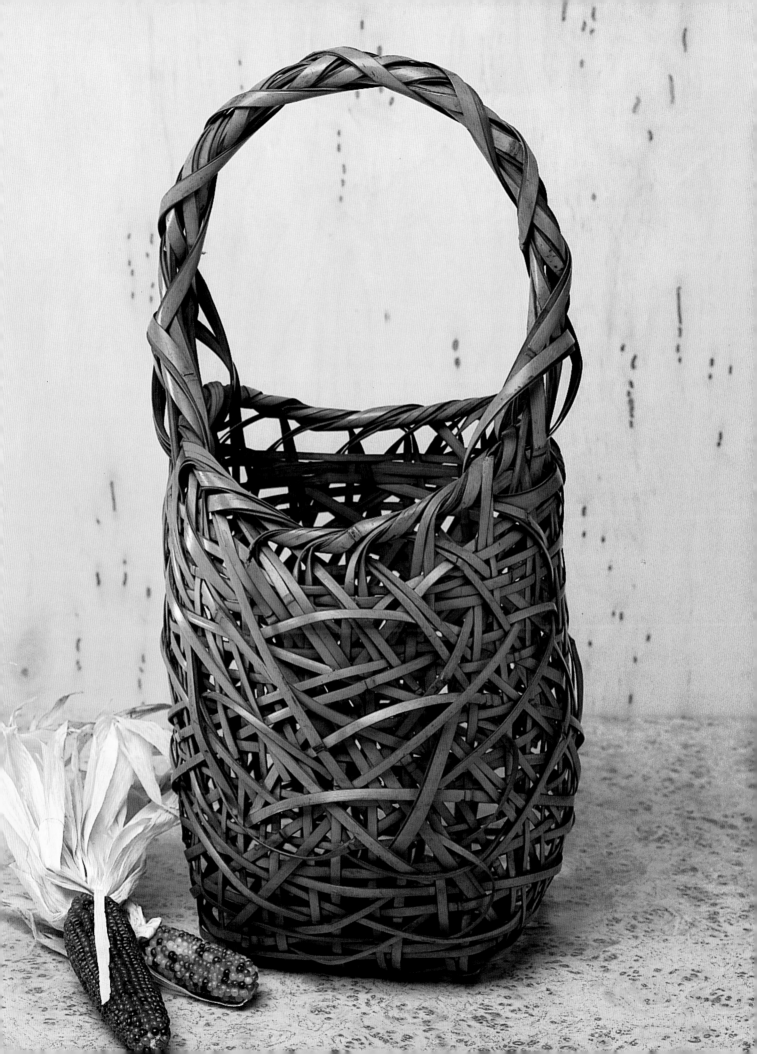

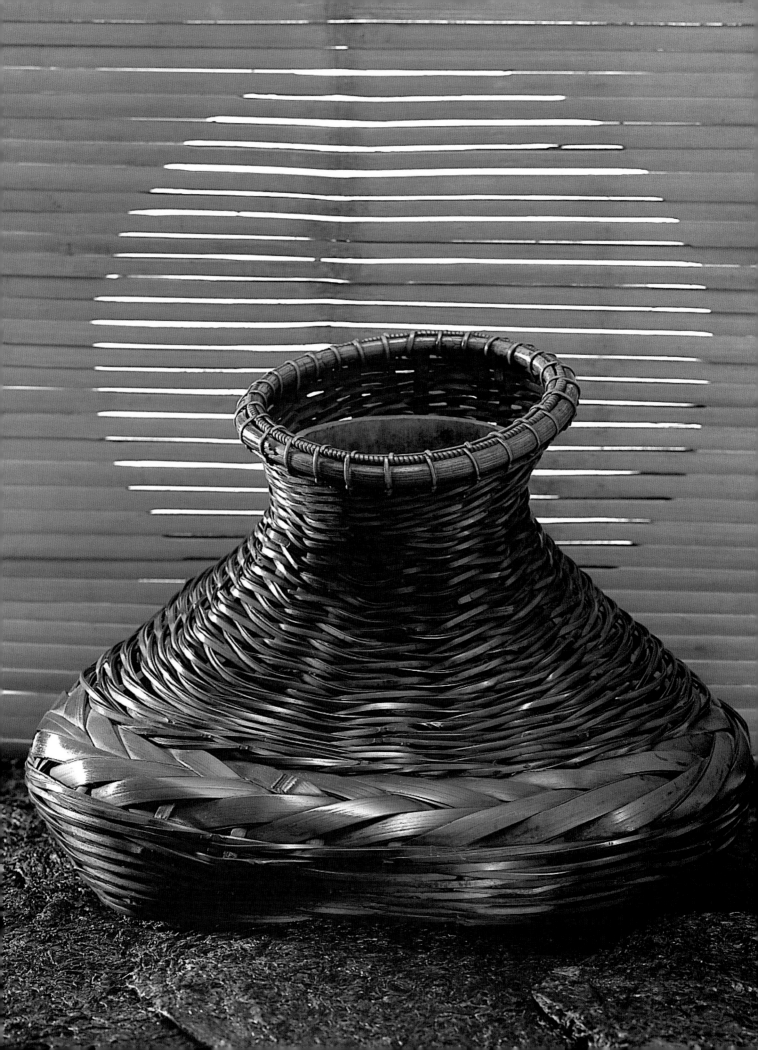

The rim, or *fuchi*, provides a sense of ending or completion to the work. As such, it should complement the rest of the basket yet also be sturdy, as it is more easily broken than the body. Warp and weft strips must be thoroughly wrapped so that they will not dislodge.

A *tomobuchi* rim utilizes the warp strips from the body of the basket; the ends of the strips being bent or interlaced to create the rim. To offset

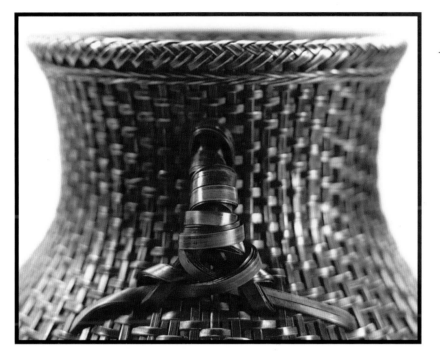

This basket expresses a freedom of spirit with its randomly wrapped handles that are in direct, but balanced, opposition to the refined karamono-like symmetry of the basket's body of even mat plaiting and tomobuchi rim.

the possibility of breaking them and ruining the basket, the strips are either moistened before working or split in two. With a *makibuchi* rim, bamboo cores are added to the basket to contain the ends of the weft and warp. These are then entirely wrapped and attached to the body of the basket with special strips created for this purpose. This forms a very sound, strong rim, making it popular for use with both utilitarian and flower baskets. The *atebuchi* rim is the most potentially decorative of rim styles. With this technique, two or more bamboo strips surround the ends of the body. These are secured to the basket

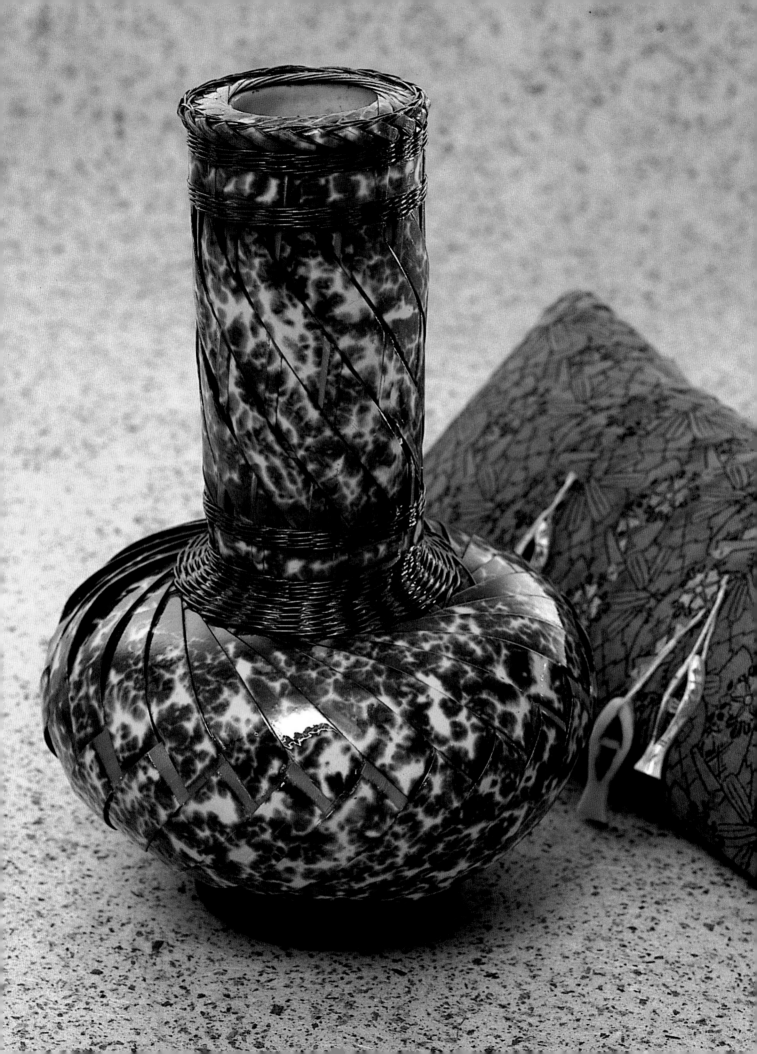

with very narrow rattan strips. Rattan's flexibility allows this to be accomplished in often elaborate ways.

Pliant rattan also proves invaluable for protecting corners and other areas susceptible to damage, camouflaging objectionable elements such as nails, affixing special features such as handles, and providing decoration. The techniques incorporating rattan include wrapping, *maki*; knots, *musubi*; and stitches, *kagari*. Initially, wrapping, knots, and stitches were mainly used on baskets in the *karamono* style, but in the twentieth century these distinctive features have been increasingly utilized with many different styles.

Wrapping may be of the simplest form or in a multitude of designs, including several that look like insects. Among the knots used, are ones called cross knot, spiral cross knot, interlocking "V" knot, double interlocking "V" knot, butterfly knot, and turtle-shell knot. Stitches may also be in the design of an insect, replicate the Chinese character for rice, or in any number of other styles.

Diagonal elements offer fluidity and motion to a basket, whether in the less-structured one shown at left, or in the symmetrically formal basket at right. Made of bamboo with markings resembling that of tortoise shell, it takes its shape from a celadon vase.

Each Japanese bamboo basket represents years of rigorous training, unstinting attention to detail, a refined level of aesthetic sensibility, and an inner spirit intrinsically connected with that of the bamboo and nature. Whether the basket is humbly rustic or regally intricate, centuries old or finished yesterday, it can be a source of pleasure and reflection for anyone who takes the time to feel all that is conveyed in its sinuous coils.

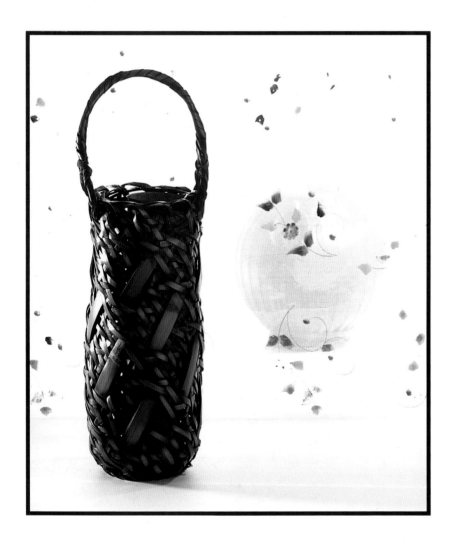

Myō, "expressing something beyond an analytical understanding," manifests as original creativity in Japanese art when rationality ceases to be the goal, the unconscious supersedes, and one's activity comes directly out of the innermost self.

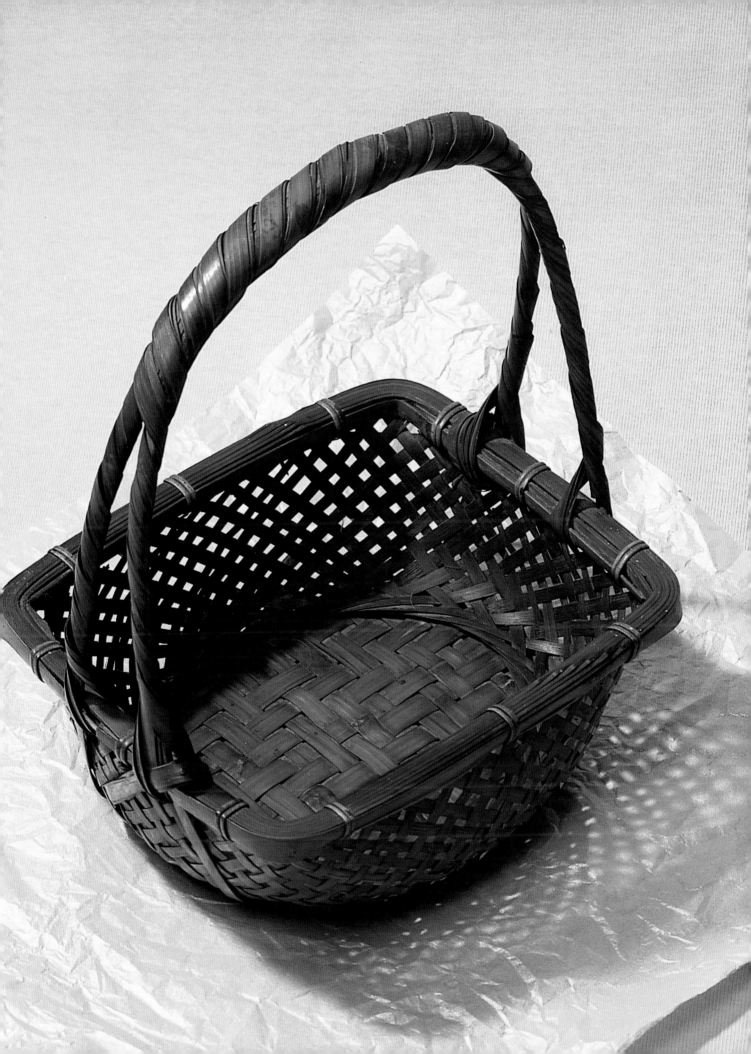

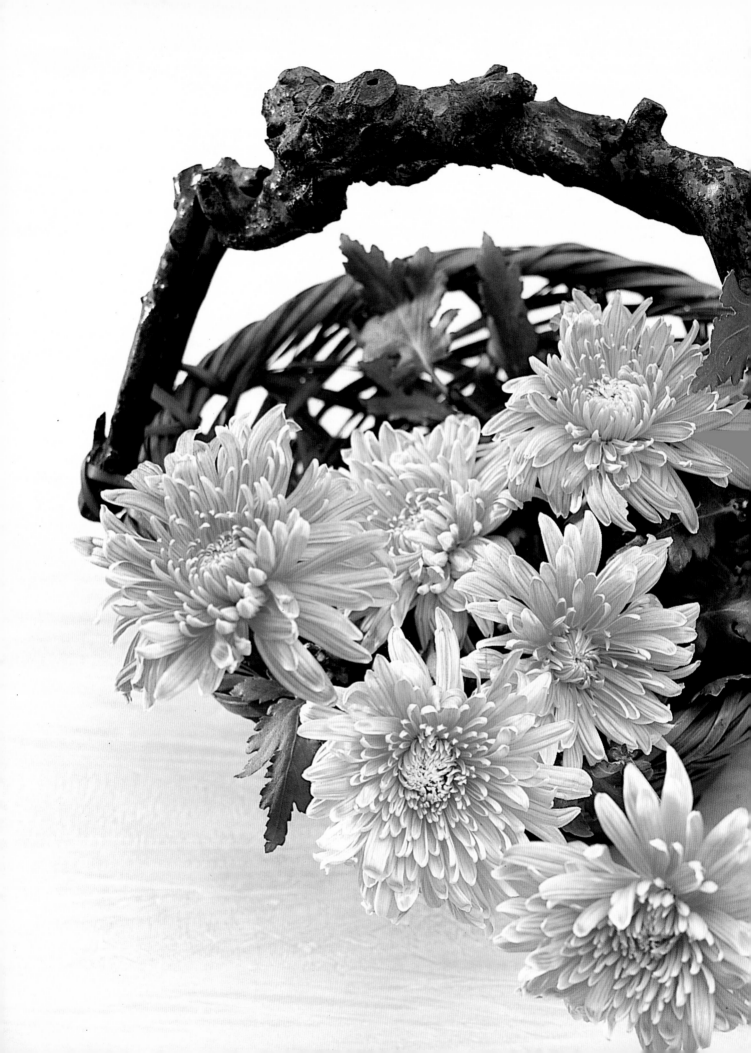

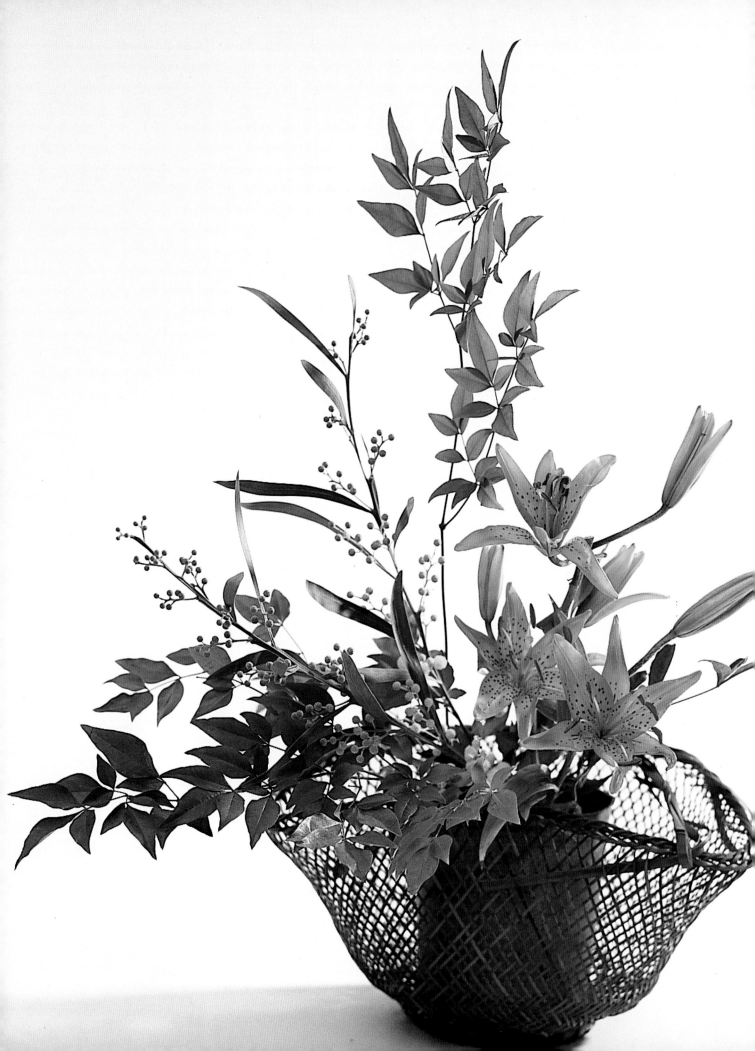

LIGHT OF THE MOON

MOVES WEST, FLOWERS' SHADOWS

CREEP EASTWARD.

BUSON

To patiently acquire insight into the beauty of nature and its relation to man's inner and outer life, and to communicate that awareness through arrangements of cut flowers and other plant material, that is the Way of Flowers, or *kadō*. Better known as ikebana in the West, it is most simply translated as "to arrange cut flowers." The unaffectedness of the definition belies the complexity of this human effort to strive for the perfection of the moment as nature pursues its will toward growth.

Evolved over six centuries as a disciplined, meditative practice and means of expression, ikebana arrangements emphasize line and space rather than mass. Though models of restraint and simplicity, the balance, rhythm, and symbolism of the arrangements make them full of life. Arresting even to the unschooled, with study ikebana yields intellectual and spiritual significance. Though expressed subtly, underlying each arrangement is the desire to give form to realities that are both tangible and intangible—the forces of light and dark, life and death, past and future, heaven and earth in relation to man.

Ikebana expresses the natural characteristics of plants, emphasizing line and space.

From religious origins in temples hundreds of years ago to secular popularity today, ikebana has gone through many changes, yielding a number of different styles serving various purposes. Although one person's perception of beauty will always differ from another's, the basic tenets and symbolic meanings formulated by ikebana masters are the result of generations of detailed observation, knowledge of nature, and artistic sensibility.

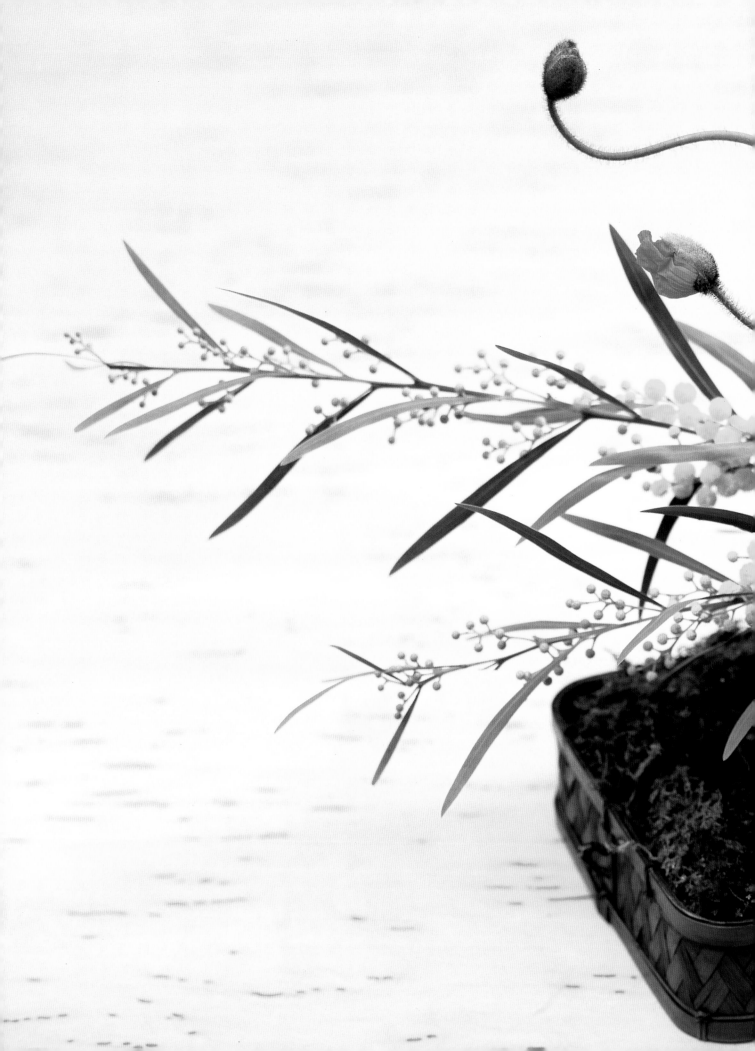

AS THE SOUND FADES,

THE SCENT OF THE FLOWERS COMES UP—

THE EVENING BELL.

BASHŌ

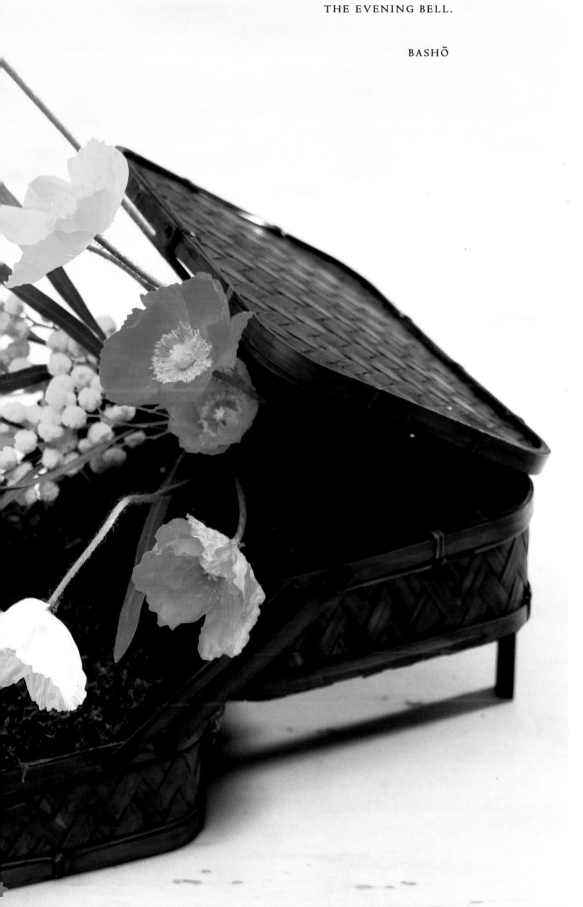

The joy of a spring picnic is epitomized in the rhythmic balance of poppies and mimosa bursting forth from a bed of moss in this bento box.

Best known among the tenets of ikebana is the arrangement's basic asymmetric triangular form composed of three main branches. These branches are referred to as Heaven (*ten*), Man (*jin*), and Earth (*chi*); Subject stem (*shu*), Secondary stem (*fuku*), and Object stem (*kyaku*); or simply as first, second, and third stems. The arrangements may be in the formal, semiformal, and informal styles (*shin*, *gyō*, and *sō*).

Whether in a boat-shaped basket or in one mimicking a multilevel bamboo culm, the basic form of ikebana remains an asymmetrical triangle. The poetry of flowers, like that of words, tells of feelings, capturing a moment in time and conveying the character of the artist.

Also taken into consideration are the four cardinal points of the compass and their relationship to the sun and time. The south, representing midday, takes the point nearest the viewer and has the greatest number of flowers and leaves facing in its direction, while the north point, or midnight, is farthest away with fewer elements. These thoughts help the arranger to keep a sense of depth and perspective.

Because early flower arrangements were placed on either side of the image on a Buddhist altar, arrangements continue to be either right- or left-facing.

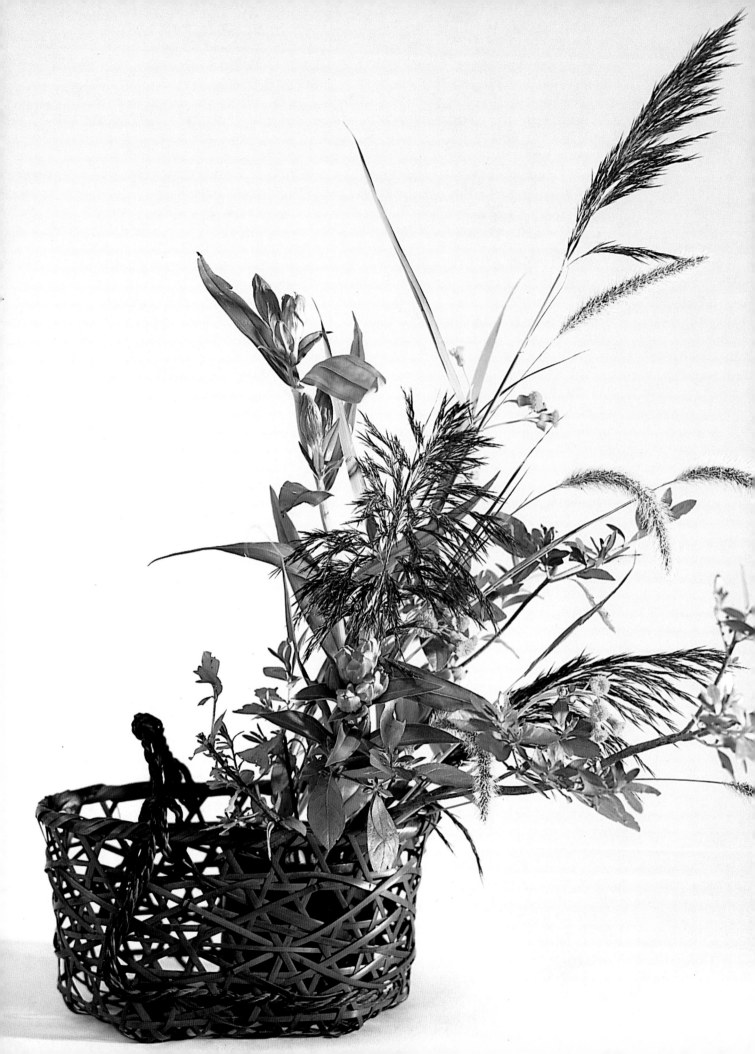

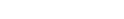

This asymmetry also represents the fluidity of ever-changing life. A right-hand arrangement, with the main stem inserted on the left is called *hongatte*, the "true" or "genuine" form. Left-hand arrangements have the main stem on the right; these are called *higatte*, the "inverse" form.

Of the greatest significance to a Japanese flower arrangement is the perception of *in* and *yo*, the Japanese equivalents of *yin* and *yang*. Representing the duality apparent in all forms, *in* and *yo* are not conflicting forces; they are complementary and essential to each other. They represent distinctions which are not made individually but in combinations and contrasts. There are, for example, the relationship of nature and spirit, space and time, female and male. *In* and *yo* are also apparent in alternations and transmutations or changes and interactions, as in night following day or spring emerging from winter.

Translating as "a banner blowing in the sun," *yo* represents light, a southern exposure, summer, strength, spiritual aspects, and activity. On the other hand, *in* implies clouds, gloom, shade, darkness, night, a northern exposure, winter, softness, receptivity, and the earth.

What is not there is as important as what is, the complementary in and yo which together form the whole.

In reference to plant material, *yo* elements include the front side of leaves, trees, flowers in their prime, the colors red, purple, pink, and variegated materials. Some *in* elements are the back sides of leaves, small flowering plants and grasses, buds and just-opened flowers, and the colors blue, yellow, and white.

Since the fifteenth century the flower masters have delineated five distinct styles: *rikka*, *shoka* (or *seika*), *nageire*, *chabana*, and *moribana*. Of ritual and formality, *rikka*, or standing arrangements, have their provenance with the imperial family, nobility, and priests of the upper class. Composed of seven or

nine principal parts to express a scene in a very formal, stylized way, *rikka* utilizes a tall metal or ceramic vase with a wide mouth, with the plant material known at times to have extended up to fifteen feet (4.5 m) in height.

Nageire, or informal arrangements, were indulged in largely by the merchant class and general public. The name is derived from *nageru-ireru*, which translates as "to toss or throw inside." Originally, this style was placed in a tall container mounted on a wall or hung from the ceiling, but today *nageire* may be used in many ways, both hanging and sitting, and in vessels of many shapes. Rustic or simple vertical bamboo baskets are especially suitable for *nageire*.

Chabana, or tea ceremony arrangements, grew out of the tea ceremony ritualized by Sen no Rikyū. A man who found beauty in singularity, he believed the flowers for the tea house's *tokonoma* should have an austerity and simplicity reflecting a tranquillity of mind and spirit, or heart, *kokoro*. Emphasizing his oneness with nature, the tea ceremony host (*shugin*) may make an arrangement comprised of a single flower or many flowers. Flowers specific to the time of year bring a temporal element of the natural world into the tea room. Together with the tea utensils and other objects in the room they express the Oneness and harmony of the universe.

Although centuries old, informal nageire arrangements are fitting for today's lifestyle as well as for tall, narrow bamboo baskets.

Rikyū preferred common, everyday items for containers. This practice influenced the development of the more relaxed and irregular *wagumi* baskets. Both are appropriate not only for *chabana* but also *nageire* and *moribana* arrangements.

Over time, the casually arranged *nageire* was melded with the complex *rikka* and spiritually oriented *chabana* into the *shoka*, or *seika*. *Shoka* arrangements utilize the asymmetrical triangular form composed of three main stems arising

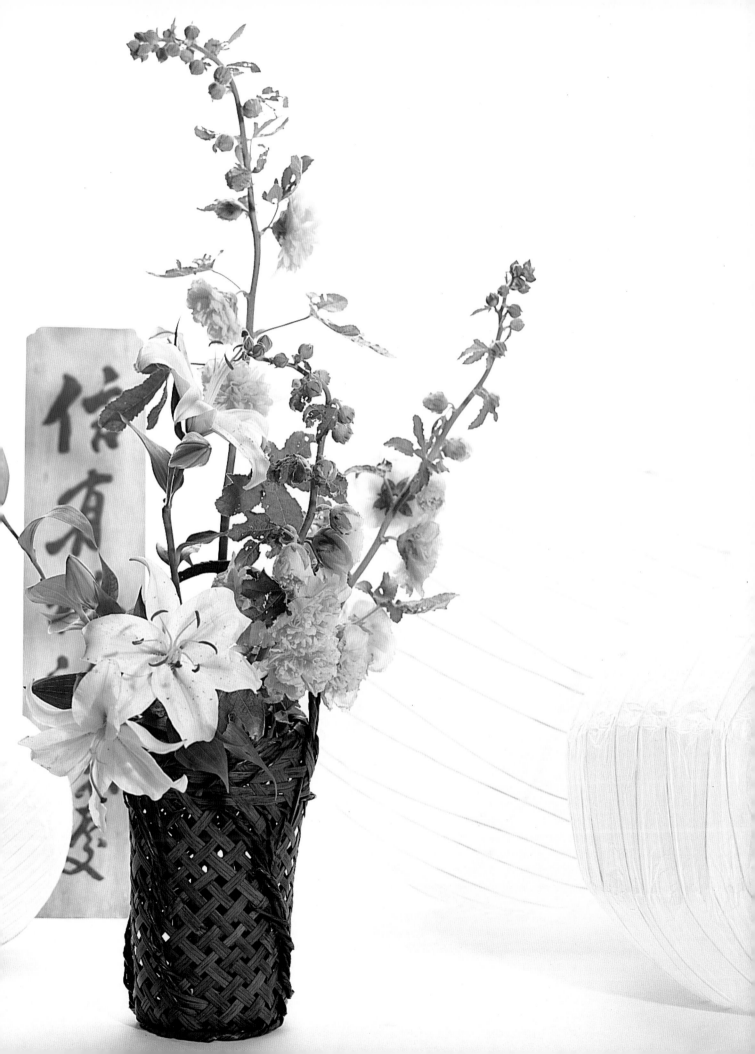

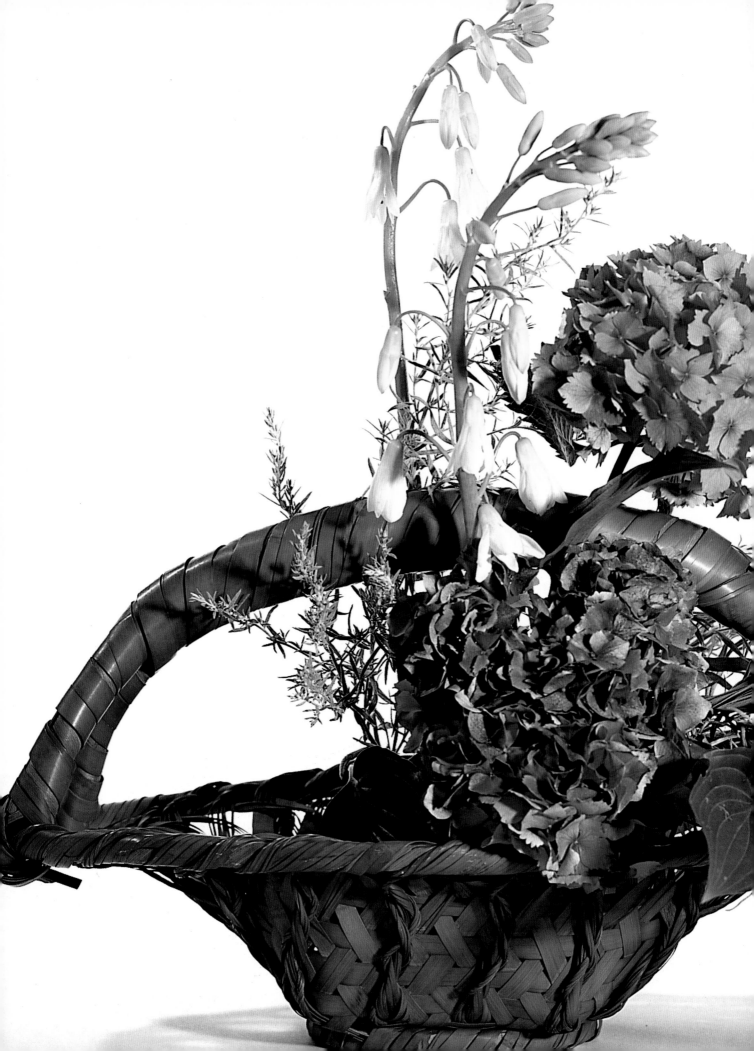

Fruit baskets, morikago, lend themselves to moribana arrangements, which are arrangements in open, shallow containers.

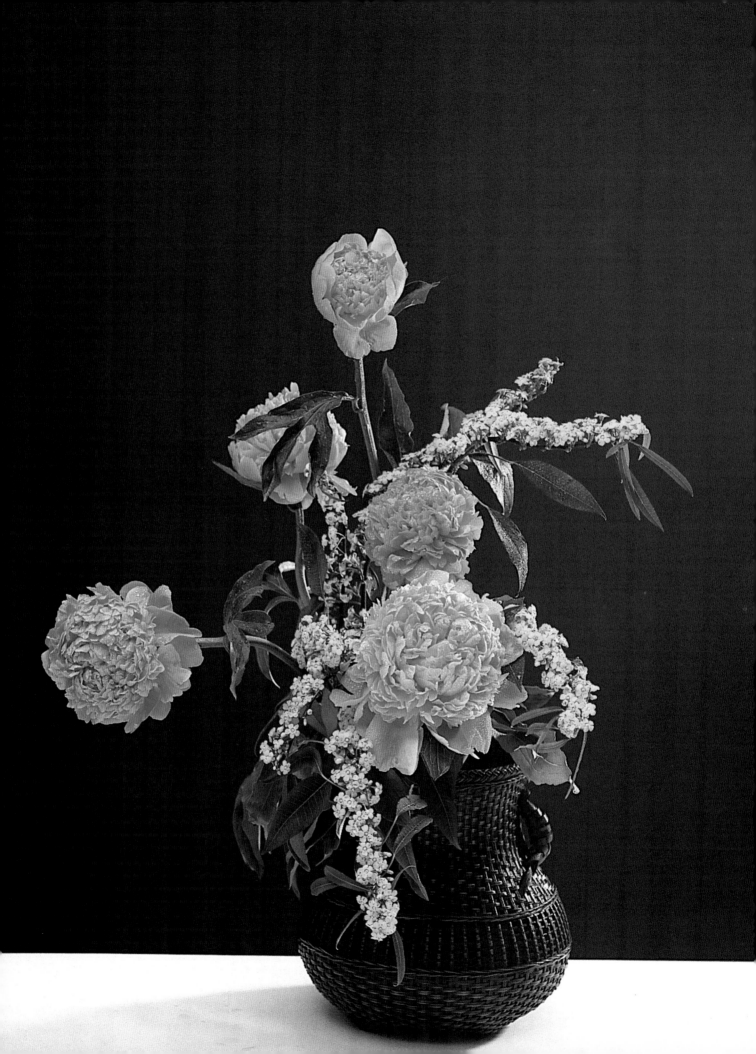

as one from the mouth of the container. The goal is to determine the basic origin of life's energy and represent it in a simple, freely creative manner, emphasizing the natural state of the flower and its individual character. Originally intended for use in the household *tokonoma*, *shoka* arrangements had widespread popularity into the nineteenth century.

With the opening of Japan to the rest of the world during the Meiji period, flower arranging and the other arts were brought into contact with Western influences. A wide range of new plant material and exposure to different aesthetic approaches brought about the advent of *moribana*, "piled up flowers in a flat basin." The term was not be taken literally; perfection was still gained with the use of the fewest possible materials. The most significant change was in the use of shallow, wide containers or bowl-like containers with an expanse of water showing. Instead of the previous emphasis on one clean vertical line, arrangements took on greater space and depth, often suggesting a landscape. *Moribana* also made use of colorful flowers from the West and *morikago*, bamboo fruit baskets first made for the tea ceremony beginning in the eighteenth and nineteenth centuries.

The evolution of flower arrangement in Japan reflects the *in* and *yo* of stasis and movement. Ikebana has changed over the years and yet remained the same. While embracing history, it has allowed itself to become modern.

Communicating through leaves, flowers, and branches, the art of ikebana enlightens and ennobles as it invites us to appreciate beauty. It is not only a link to the magnificent natural world outside of us, but an opportunity to be contemplative and to find inner peace.

Over time ikebana has adapted to change. Although the basket and peonies are classical in combination, the arrangement is of a modern, informal style.

*Arrangements of seasonal
fruit came with artistic
freedom wrought by the
sencha ceremony of the
1700s and 1800s.*

ADD A PAIR OF WINGS
TO A PEPPER POD, YOU WOULD
MAKE A DRAGONFLY.

BASHŌ

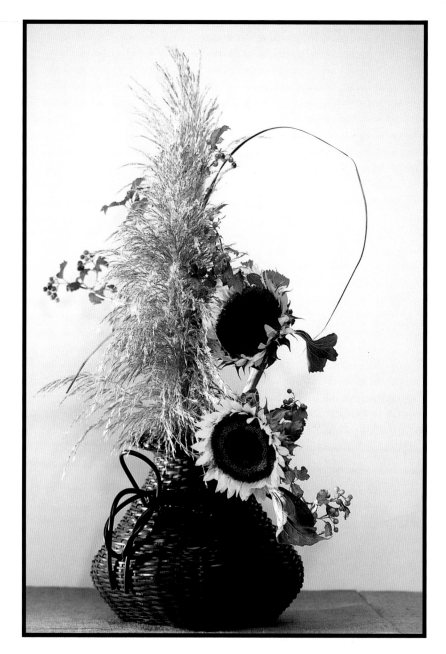

With calmness and meditation, ikebana brings together harmony and asymmetry, elegance and simplicity, nature and culture, the transitory and the timeless. More than the placement of cut flowers, ikebana communicates life's essence.

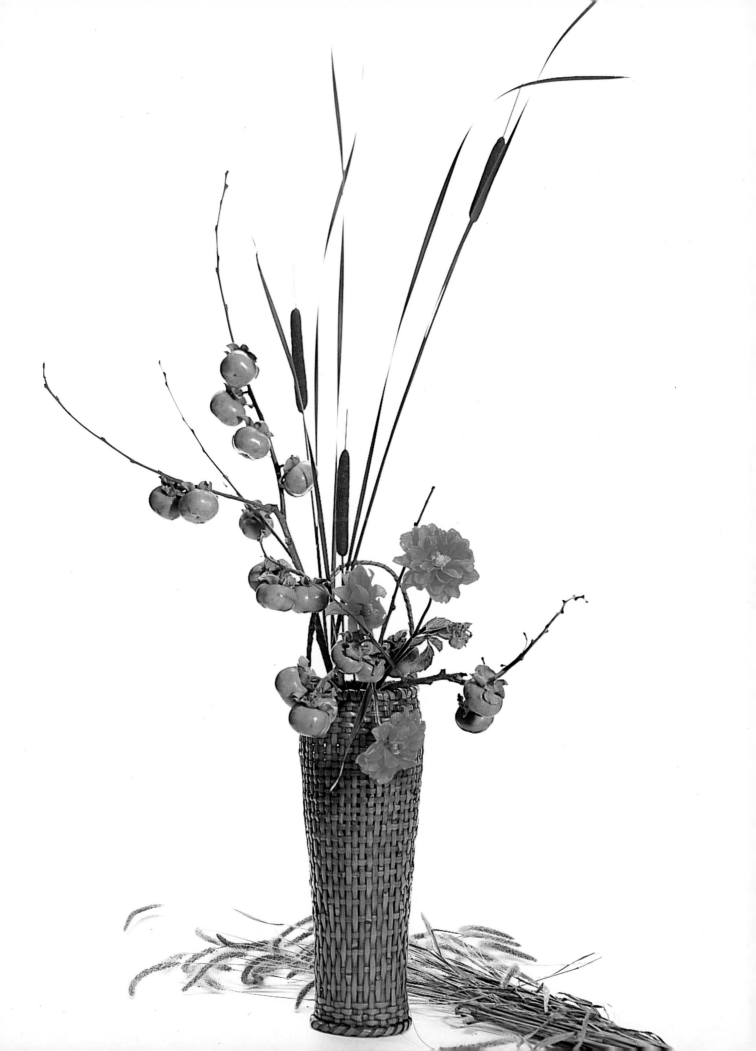

CREATING
IKEBANA:
DELIGHT
AND
COMPOSURE

BEFORE THE WHITE CHRYSANTHEMUM

THE SCISSORS HESITATE

A MOMENT.

BUSON

Japanese bamboo baskets are ultimately objects of function as well as beauty. Whether the basket is specifically made for flowers or one adapted to that use, it is with the addition of an ikebana arrangement that it is given life, completing the whole.

Ikebana is a joyous art that transcends cultures and time. Through it a person is able to study nature in a creative way. The practice of Japanese flower arranging also leads one from the discordance of everyday life to a calm, centered state of mind, body, and spirit. Over the centuries, ikebana has been able to honor the past and maintain its integrity while adapting to plant materials, techniques, technology, and lifestyles from around the world. Although hundreds of schools of ikebana have evolved, three have predominated.

Founded in the fifteenth century, the Ikenobo School was the first. As might be expected, its teachings are the most traditional and classical.

The act of arranging flowers in a bamboo basket carries on an ancient tradition. The essentials are flowers, scissors, and a waterproof container.

At the other end of the spectrum is the Sogetsu School, founded in 1925 by Sofu Teshigahara. Sogetsu arrangements emphasize freedom of expression and a relationship to contemporary sculpture. Suitable to all surroundings, any type of plant material or container may be used, but the depth of symbolism and philosophical meaning inherent in ikebana is never abandoned. The Ōhara School was founded in 1895 by Unshin Ōhara, the originator of the *moribana* style of arrangement. It combines many of the traditional ikebana tenets with a

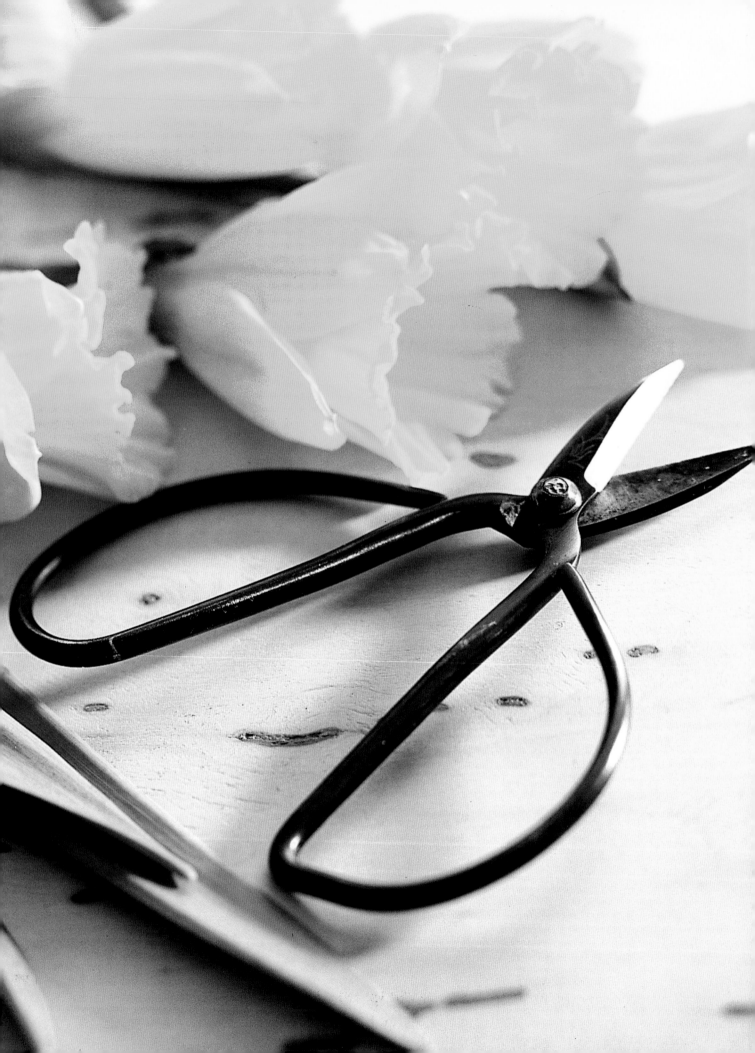

naturalistic approach to plant material. It is the only school which has evolved a sophisticated method for creating landscape arrangements. The arrangements in this book are in the manner of the Ōhara School.

As with any art, earnest study and firsthand experience with a teacher is the best means of learning. The ensuing explanations for creating ikebana are meant to give only the most basic of introductions. The hope is that they will inspire the reader not only to seek out more comprehensive books but also, preferably, a class. In the beginning, tools and materials already in the home will probably be adequate for ikebana arranging, but as one continues, other items that are specially designed for ikebana will be necessary.

Traditional Japanese scissors have handles resembling a butterfly or uncurling fern fronds. Use these or other scissors to cut flower stems under-water before arranging.

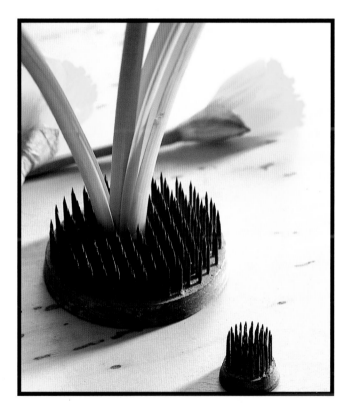

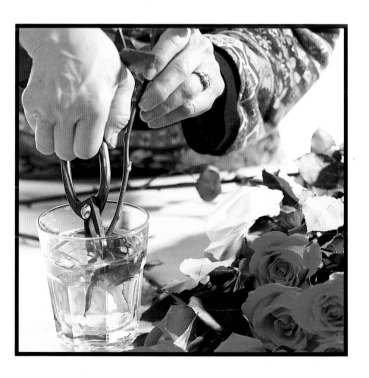

Available in a variety of sizes and shapes, heavy metal needle-point holders, or kenzan, allow precise placement and angling of stems in the shallow, open containers of moribana.

113

To maintain the placement of stems in narrow-mouthed containers, use braces or stays, called tome-gi.
A heavy branch is supported by splitting its base, inserting a piece of branch exactly the length of the container's diameter, affixing it with wire, and then wedging it into the container.

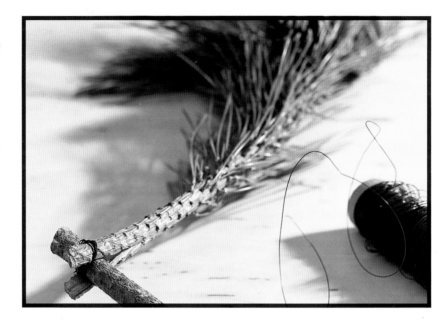

With razor-sharp edges, the Japanese scissors called *warabi-te* are traditional. The translation is "bracken-handled" because the handles resemble the curled shoots of emerging fern, or bracken, fronds. The "butterfly-handled" Japanese scissors are also appropriate. Available in a range of prices, select a pair that feels right for your hands. Oil them occasionally to keep them in shape. A sharp knife, heavy pruning shears, and small pruning saw are also useful.

Because the exact position of flowers and stems is so crucial to ikebana, a number of methods for holding them in place have been devised. For low, open *moribana* arrangements, needle-point holders, or *kenzan*, are the most common. They consist of a heavy metal base out of which numerous "needles" arise. *Kenzan* are available in small, medium, and large sizes—in square, rectangular, round, and quarter-circle shapes as well as in a "sun-moon" pair. Which of these and how many are used depends on what fits best into the container. A needle-repairer will straighten needles if they become bent. Rounded pebbles are used by some people to cover the *kenzan*.

To reinforce or lengthen a stem, another piece of stem is securely attached by wrapping it with florist wire in two places. Be sure that the cut end of the reinforced plant material is underwater in the arrangement.

Whether using braces or stays to support a heavy branch, removing unnecessary leaves and flowers, or bending a branch or stem to create a line, the goal is to retain the integrity of the plant material while expressing its character.

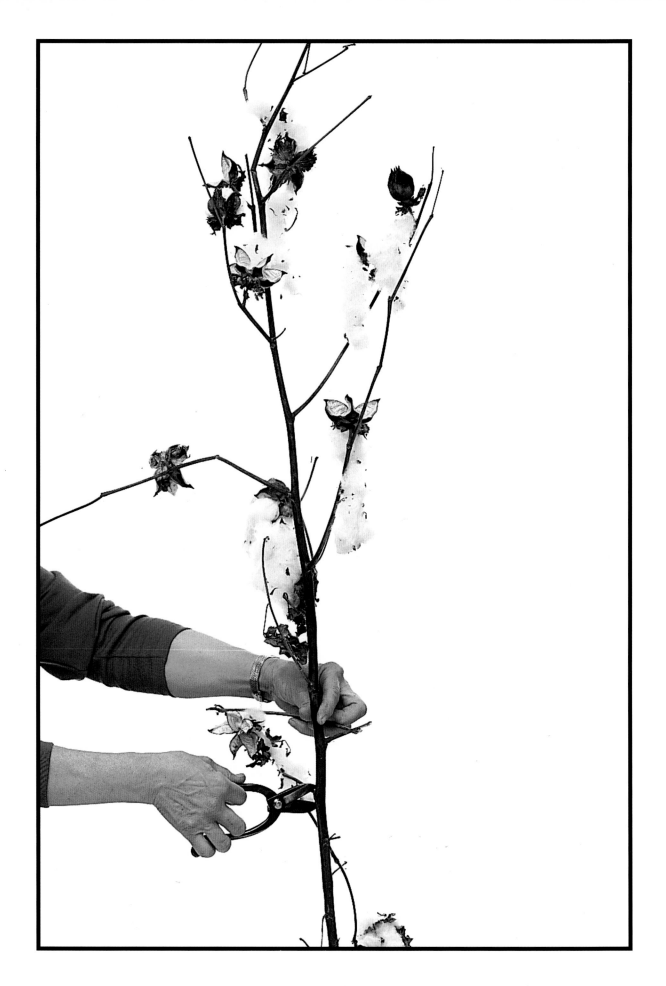

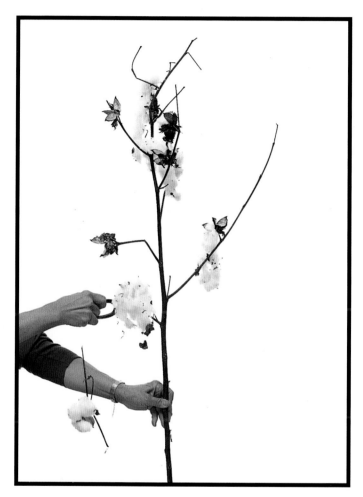

The preparation of plant material
includes trimming to remove damaged
parts or extraneous aspects that are
superfluous to the line.

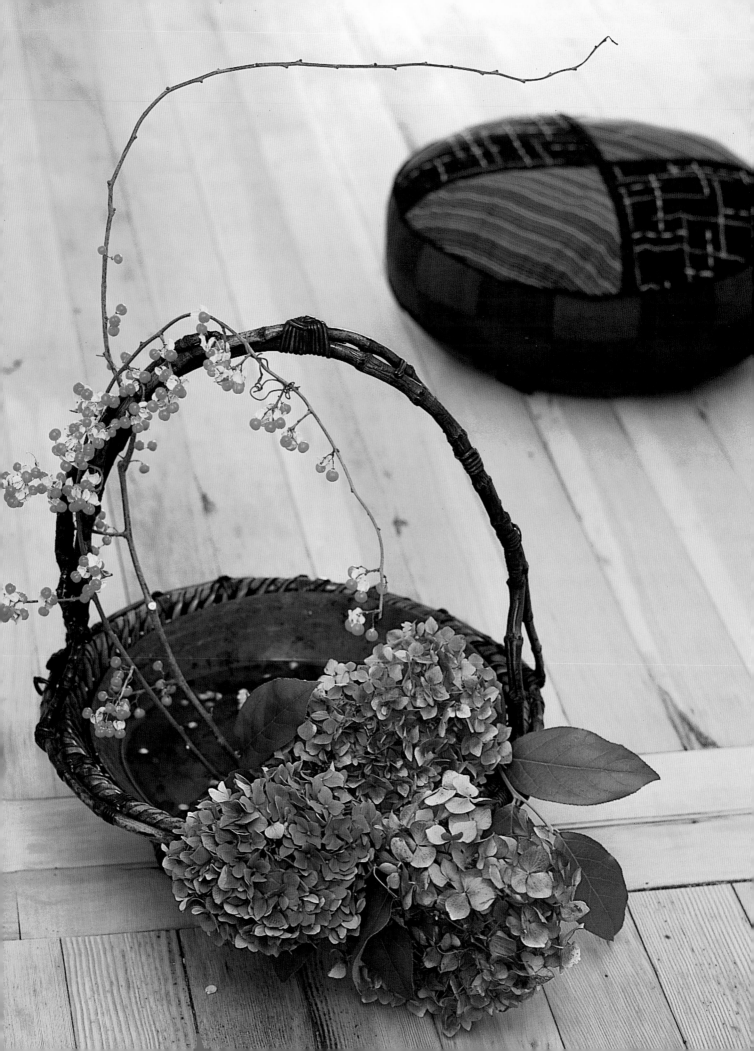

The plant stem is inserted upright into a *kenzan*, then tilted in the desired direction. If a stem is especially thin or top-heavy with flowers, it is "thickened" by inserting it into, or tying it to a short length of thicker stem. Heavy branches are supported with a short forked branch.

For *nageire* in tall, vase-like containers with small openings, *tome-gi*, or braces and stays, are used to hold the stems. *Kubari* are vertical stays, the simplest being a forked twig. A *komi* is a horizontal piece the size of the diameter of the container, used alone or laid at a right angle to the *kubari*. Another possibility is to crisscross two small twigs just below the opening of a cylindrical container. Or, a single branch can be held in place by splitting its base and inserting a short twig that just fits the diameter of the container into the split and tying it. Florist's wire or fine cord may be used for tying. For an upright arrangement, interlock the split ends of two branches, one that shows and one that is hidden. For spherical containers, a vertical branch that is almost the height of the container is tied at a right angle to a horizontal branch slightly longer that the diameter of the opening. These and other methods can be used, depending on the container and the characteristics of the plant material.

Pebbles may be used to hide and anchor the kenzan in a moribana arrangement. Plant material is often used to repeat the line of the handle but should never totally obscure it.

PLANT MATERIALS:
1) Hydrangea
2) Lemon leaf
3) Bittersweet

BASKET:
Morikago or fruit basket, of
sooted bamboo (sus take).
Multiple-stemmed nboo
handle with decora e knots.

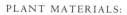

STEP 1:
*Choosing an unobtrusive
container to hold the water
and the plant material in
an open basket is a challenge.
In this case, a tarnished
copper bowl that fits
snugly inside came with the
basket. An inexpensive
alternative would be a clear
glass or plastic plant saucer.*

STEP 2:
*Although a kenzan is
usually necessary for a
moribana arrangement in
a low, open container, by
selecting plant materials
and an appropriate design,
it is possible to make an
arrangement without one.
To establish the Subject,
wire two heads of hydrangea
flowers together and rest
them on the edge of the
basket. The feeling of strength
comes from their mass.*

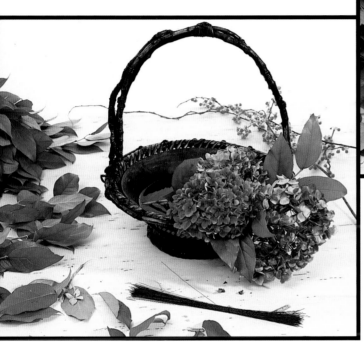

STEP 4:
*For balance, use stem of
bittersweet vine to define
the space in the rest
of the arrangement and
to emphasize the handle.*

STEP 3:
*Hydrangea retains
its shape and form and
varies in color from bright
blue-purple to green and
purplish-brown. For emphasis
and focal point, a single stem
of blue hydrangea is used.
Add lemon leaves as needed
for filler. Keep the material
in proportion to the diameter
and height of the basket.*

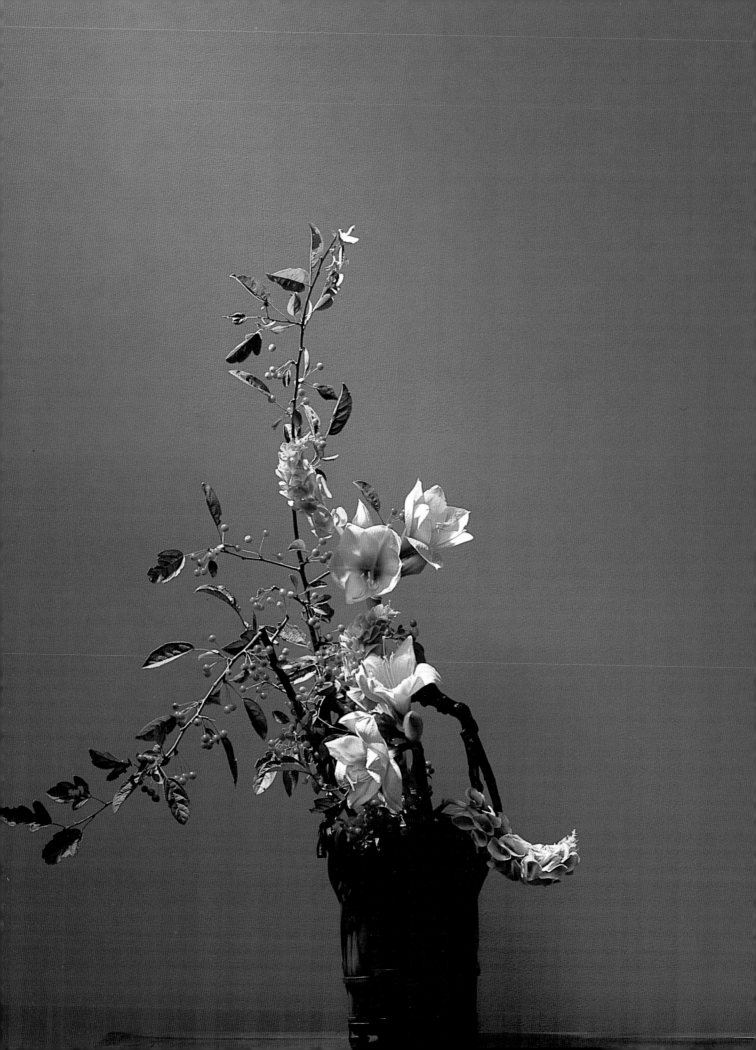

A water sprayer literally and figuratively gives life to an arrangement. Specially made ones have reversible heads that turn them into pumps for forcing water into the stems of aquatic plants. A water-change pump, a siphon used to change water in containers, is useful. There are also a number of different materials, both commercial and household, which may be added to the water to delay the decay of plant materials.

When using a basket, a container for the water must be hidden inside. This can be anything that holds water and does not impede the design of the arrangement. It may be necessary to paint the container to make it unobtrusive. The decision of whether to use a valuable basket for a flower arrangement is always difficult. However, if proper attention is given to the water holder, the basket should in no way be jeopardized. If in doubt, there are certainly many baskets of moderate value that can enhance the beauty of flowers.

To say that there is a wealth of plant material available from gardens and flower shops is an understatement. When cutting your own material from the garden, the best time is early- to mid-morning before the dew has evaporated. When finished gathering, immediately plunge the stems into a bucket of tepid water. Recut the stems under water, and place the material in a cool, dark place for at least several hours to condition.

When ready to arrange, recut the stems at an angle under water again. Next, extraneous material should be trimmed off. This is a critical process in Japanese flower arrangement. The goal is to enhance the beauty of the plant material, to bring out or better express special characteristics of line, all without destroying its true nature and beauty. Bruised or torn flowers and leaves are usually removed or trimmed. Branches that cross each other are removed or bent.

With ikebana comes discovery of line, pattern, color, and the growing habits of plants. The opening amaryllis buds show lively energy, the berried branches denote time's passage, and the Bells-of-Ireland's tender green balances the peach color of the amaryllis.

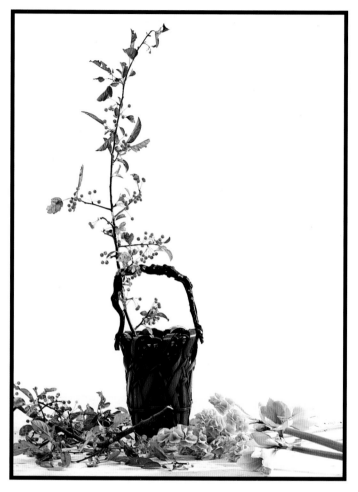

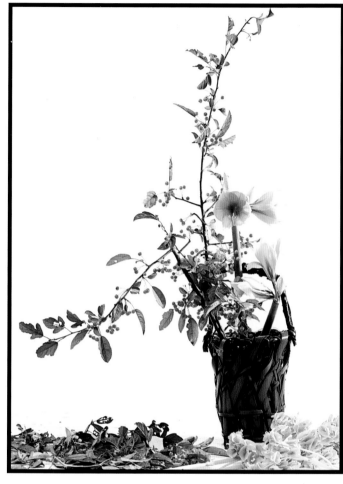

PLANT MATERIALS:

1) *Amaryllis*
2) *Crabapple*
3) *Bells-of-Ireland*

BASKET:

Strips of different widths used in twill-plaiting with various intervals of strip pass-overs. Tomobuchi rim and twisted-root handle.

STEP 1:

Place a waterproof container in the basket. Although damaged leaves are usually removed, these bug-eaten ones provide a feeling of time's passage and the frailty of things, while the tiny apples reflect fruition. The tallest stem is 1½ times the basket's height and width.

STEP 2:

Trim a branch of crabapple to create a downward angle, and bend the tip upward. Add stems of just-opening amaryllis to offer a contrast of rebirth. To hold the stems precisely in place, crosspieces of crabapple branches are wedged precisely into the container below the rim.

STEP 3:

*Fill in the nageire arrange-
ment with stem of Bells-of-
Ireland. With papery green
flowers, this filler material
unifies the arrangement.*

STEP 4:

*Being originally displayed
in a recessed tokonoma,
ikebana was intended to be
viewed only from the front.
With careful planning, in
order not to lose its inherent
look, an arrangement can
be adapted to be viewed
from all sides.*

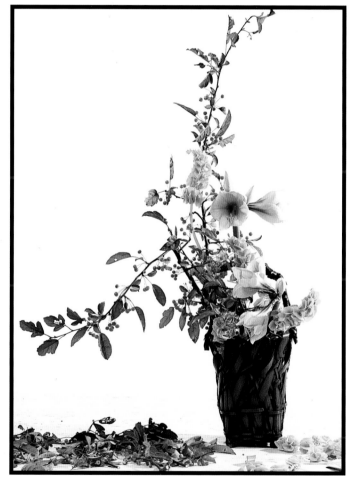

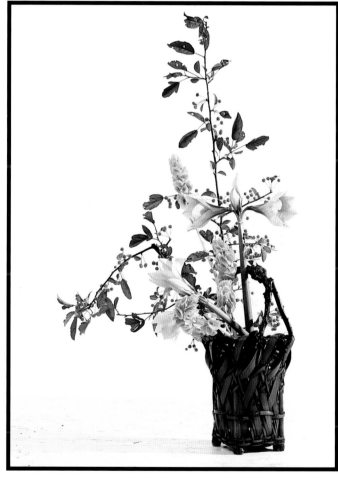

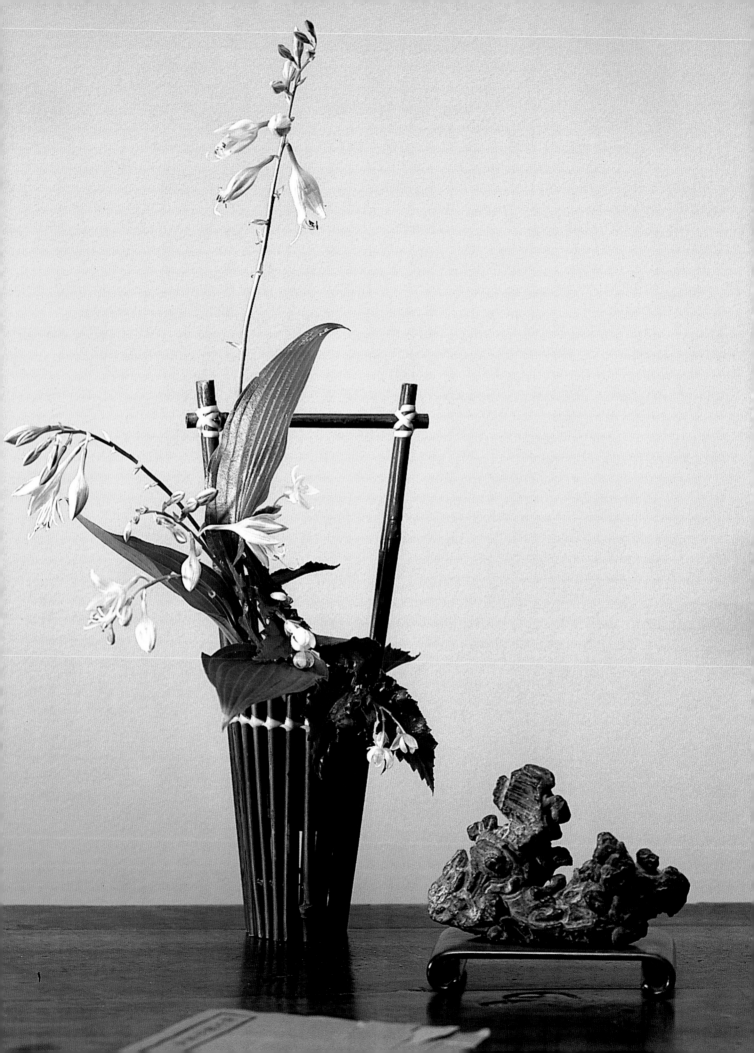

Learning to bend branches, subjugating them to your will, is one of the key skills in ikebana. A branch is worked keeping both hands close together, and several curves are often necessary for the most graceful line. Thick or brittle branches may be shaped by making a small cut and inserting a wedge. Usually more fragile, flower stems are twisted and nicked simultaneously to keep them from snapping. The tip of the branch or stem should always turn up, as it grows in nature, seeking the light and sun.

The first step in creating a harmonious arrangement is studying the plant material to determine the best form, style, and container. The fundamental forms in the Ōhara School are *moribana*, shallow container arrangements, and *nageire* or *heika*, vase arrangements. Adapting to reduced modern living space and the needs of beginners to more readily achieve successful results, Hōun Ōhara, the third Headmaster, has also devised the simplified small-form arrangement.

There are four styles of the small form arrangement, two upright and two slanted, and two principal stems are used. The Subject is the main stem, the line, the masculine element of the arrangement. Always the longest stem, it also has the greatest strength, most interesting shape, more beautiful appearance, or brightest color. Even when the Subject consists of flowers rather than branches, the largest and best shaped is the Subject. The Object stem is the mass, feminine, balancing, and focal element of the arrangement.

The Ōhara School developed the small form of ikebana to work in smaller spaces in contemporary homes yet still retain the fundamentals of Japanese flower arranging. Hosta and begonia from the garden border are used here.

PLANT MATERIALS:
1) Hosta
2) Begonia

BASKET:
*Marutake kumimono,
constructed from
unsplit bamboo culms.
Bamboo handle.*

STEP 1:
*Wedge short branches
horizontally into the
container. Place three
curving hosta stems to
establish the lines, the
tallest being the Subject.*

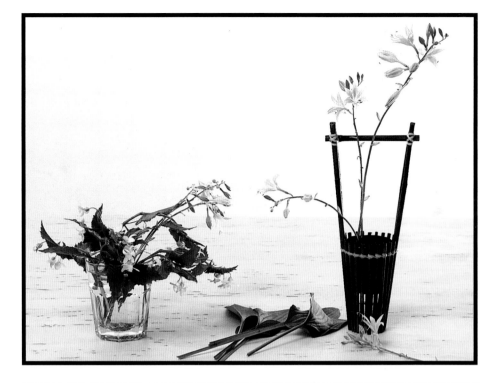

STEP 2:
*With such delicate material
and a high, thin handle,
determine the length of the
stems by adding only the
height of the basket's body
and diameter. Calculated
by the amount showing
above the rim, make the
longest stem 1½ times the
total, with the other
two stems about ⅔ and ⅓
as long. Curved hosta leaves
emphasize the handle.*

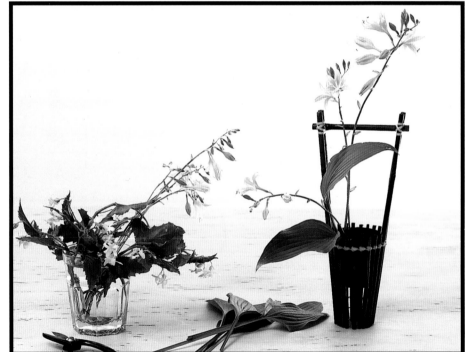

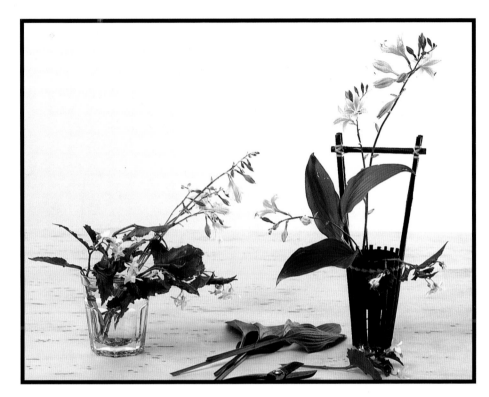

STEP 3:

Add another hosta leaf to unify the upper and lower elements. Adding stems of begonia as the Object and filler of the arrangement, provides the Japanese "balance" of disparity. The tips of the outermost stems form an irregular triangle.

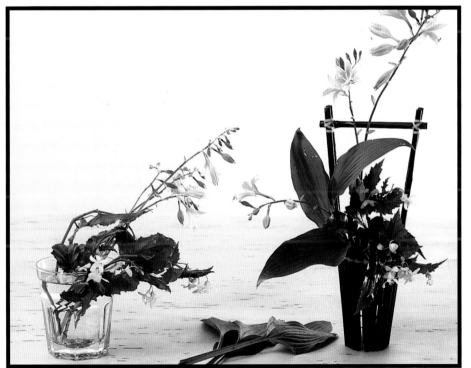

STEP 4:

Recutting each stem underwater, continue adding begonias, being careful not to not bunch them up. Make them appear to grow naturally out of the basket without crowding. Even though the stems are short, they are easily used in a tall basket when there is good placement of crosspieces as stem holders in the container.

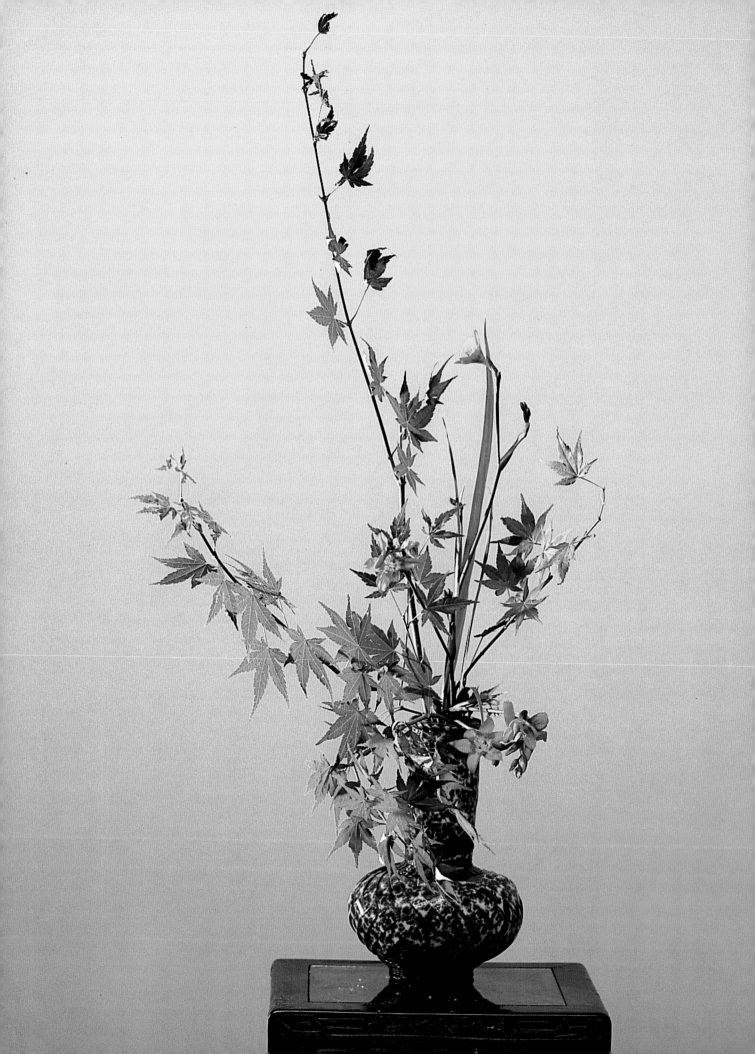

Additional plant material, consisting of the same already used or a third variety, known as filler, completes the arrangement. This may provide accent, contrast, movement, mood, atmosphere, or the unexpected. Filler material is not governed by rules, but must adhere to the limits of space allotted to it in the specific style. Fillers allow the arranger more freedom to express his personality.

When creating an ikebana arrangement, it is important to keep in mind a sense of space as well as depth and perspective, working on the diagonal from back to front rather than left to right. It is important to note that all ikebana arrangements pitch forward. This is because they were originally always placed in a *tokonoma*, with closed back and sides, where only a direct frontal view was possible.

The proportions of the main stems showing above the rim of the container are determined by the container. For an arrangement in a low container, the Subject stem is 1½ to 2 times as long as the total of the diameter plus the height of the container. The Object stem is ⅓ to ½ the length of the Subject. For a tall, vase-like container, the Subject is 1½ to 2 times the height of the container at point of emergence, and the Object is ⅓ that length.

Japanese maple is greatly enjoyed in Japan, and this arrangement utilizes its power to balance the mottled bamboo basket, while orange flowers reflect its colors.

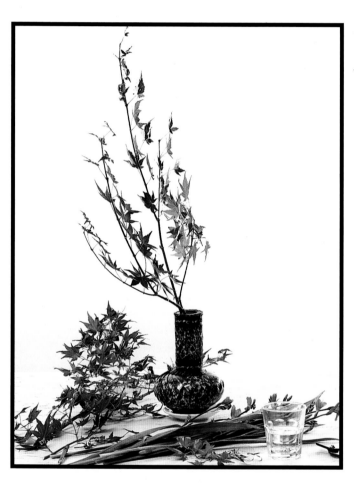

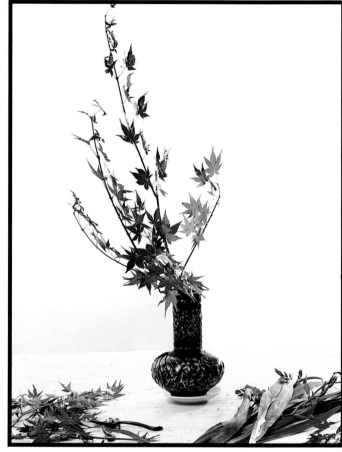

PLANT MATERIALS:
1) Montbretia
2) Japanese maple

BASKET:
Classic celadon-vase shape
using wide strips of mottled
bamboo accented with bands
plaited of thin strips of
sooted bamboo.

STEP 1:
Insert a waterproof
container. Trim branches,
removing extraneous
branches and leaves so the
delicate tracery is accented.
Cut the longest stem that
shows above the rim to
1½ times the basket's height
and width.

STEP 2:
Add several more tall
branches, not letting them
crisscross. The beauty of
each should be visible.
If a branch does not have
the desired angle, gently bend
it to reshape, working with
your fingers close together.
Add short branches closer
to the mouth of the basket
at the front edge, partially
camouflaging the rim and
cascading over it.

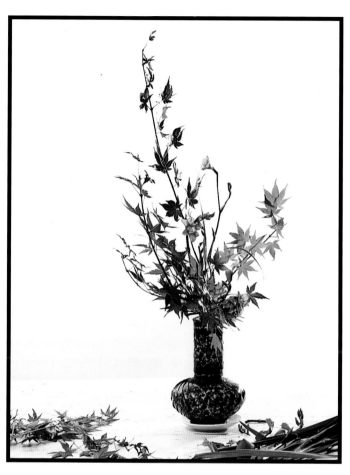

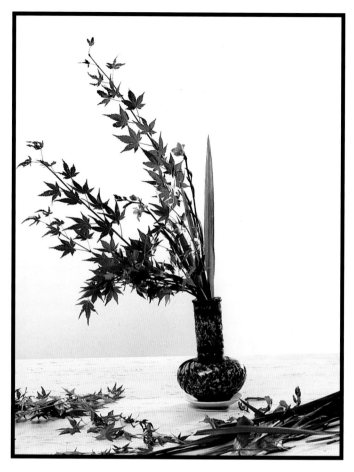

STEP 3:

*Orange montbretia brings
personality and the colors of
the basket into the arrange-
ment. Remove some flowers
and buds on the tallest
stem of montbretia and
cut to ½ the length
of the longest maple stem.
Place it in profile to converse
with the tall maple stem.*

STEP 4:

*Creating depth
in an arrangement is an
important aspect of ikebana.
This side view shows how
much plant material is
pitched forward. Use
montbretia leaves for filler,
as they emphasize the lines
of the tallest flower stem
and also provide a clean,
linear contrast to the maple
leaves. A vase with a
narrow opening may not
need crosspieces to hold
the stems in place.*

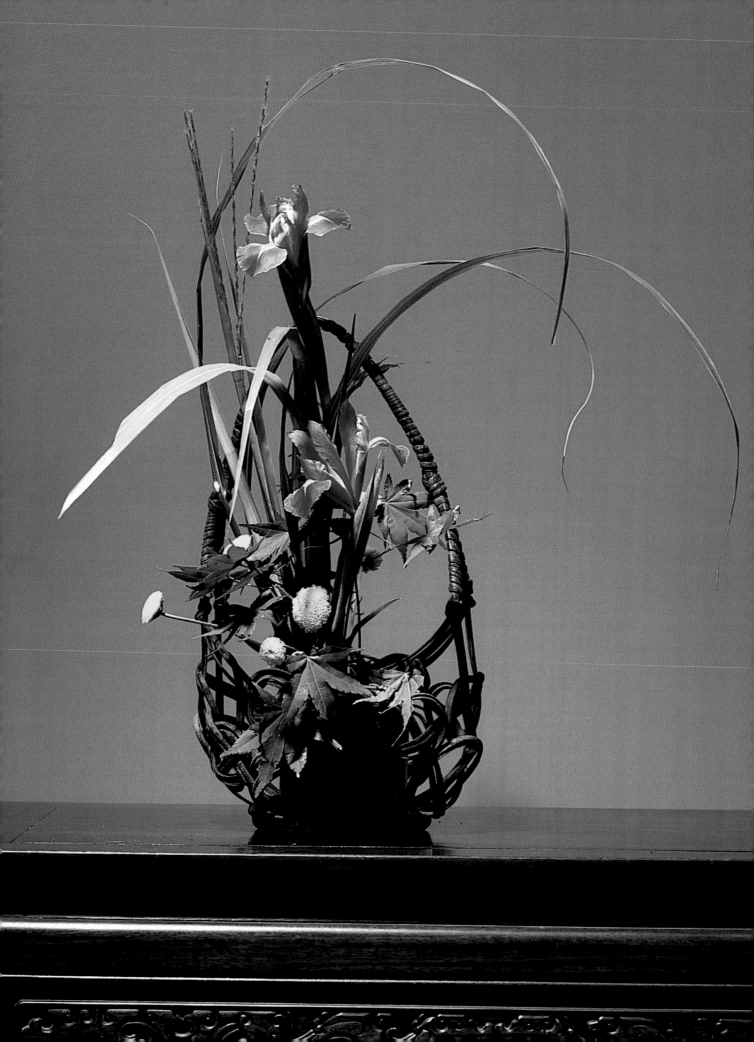

These lengths also vary depending on the material. For roses and chrysanthemums, the length is measured from the base of the flower. Larger flowers like peonies or lilies are measured from the bottom tip of the full bloom. Flowers with very long heads, like gladioli, are measured from the bottom third of the flower spike. Flower spikes with shorter heads, like snapdragons, are measured from the bottom of the bloom. Depending on the shape of the plant material and where the arrangement will be placed, an arrangement may face to the right or left.

With *moribana* and *nageire (heika)* arrangements there are three principal stems, the Subject, Secondary, and Object. Some basic styles are: upright, slanting, cascading, heavenly, and contrasting. Variations and freestyles are also possible.

With the inherited beauty of bamboo baskets, arrangements that focus on plant materials with seasonal synchronicity or geographic propinquity create a unity as of being among friends. Creating a symbiotic relationship of a basket and flowers is a meditative experience that nurtures inner feeling of contentment and awareness of the unity of man, nature, and sprit.

The traditions of bamboo basket making and ikebana arrangement help us nurture *wabi*, the appreciation of the commonplace. Both show the beauty and abundant possibilities present in even the most common plants. We see this whether in the rustling of bamboo in the wild, the color of bamboo stained by smoke in a thatched roof, or in a single morning glory carefully arranged in a basket of unusual beauty. Bamboo baskets, with flowers or alone, are a source of everyday pleasure and sublime enjoyment.

Exuberance and joy, freely expressed in an open-weave basket with grass, maple, iris, and mums, are delicately balanced with the elements of grace and restraint.

PLANT MATERIAL:
1) *Japanese maple*
2) *Button mums*
3) *Iris*
4) *Miscanthus grass*

BASKET:
*Morikago, or fruit basket,
with open-plaited bamboo
strips of even width.*

STEP 1:
*Place a container and
kenzan in the basket. Prune
maple branches to accent
natural lines. Add a branch
echoing the curve of the
handle and another that
follows the basket's front.*

STEP 2:
*For an upright style, the
concentration is always on
the main stem. Let it reach
up toward heaven and be
about 1½ times the height
of the basket, plus
the width at the widest
point. Remove all withered
blossoms from the irises.*

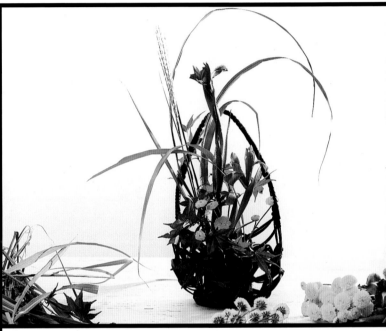

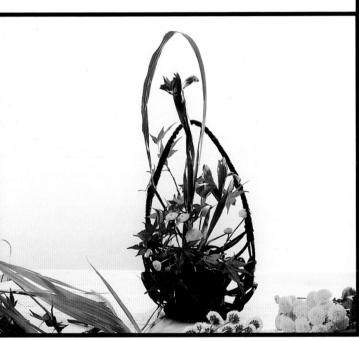

STEP 4:
*Keeping heights proportional,
add grass as needed. Finally,
place an opening grass
flower at the same angle as
the tallest iris.*

STEP 3:
*To contrast with the irises,
add yellow button mums.
Make sure the angles
and heights are varied,
considering positive and
negative space. Manipulate
the grass leaves to give the
arrangement a sense of
movement, stroking them
from stem to tip with wet
fingers for a gentle curve.*

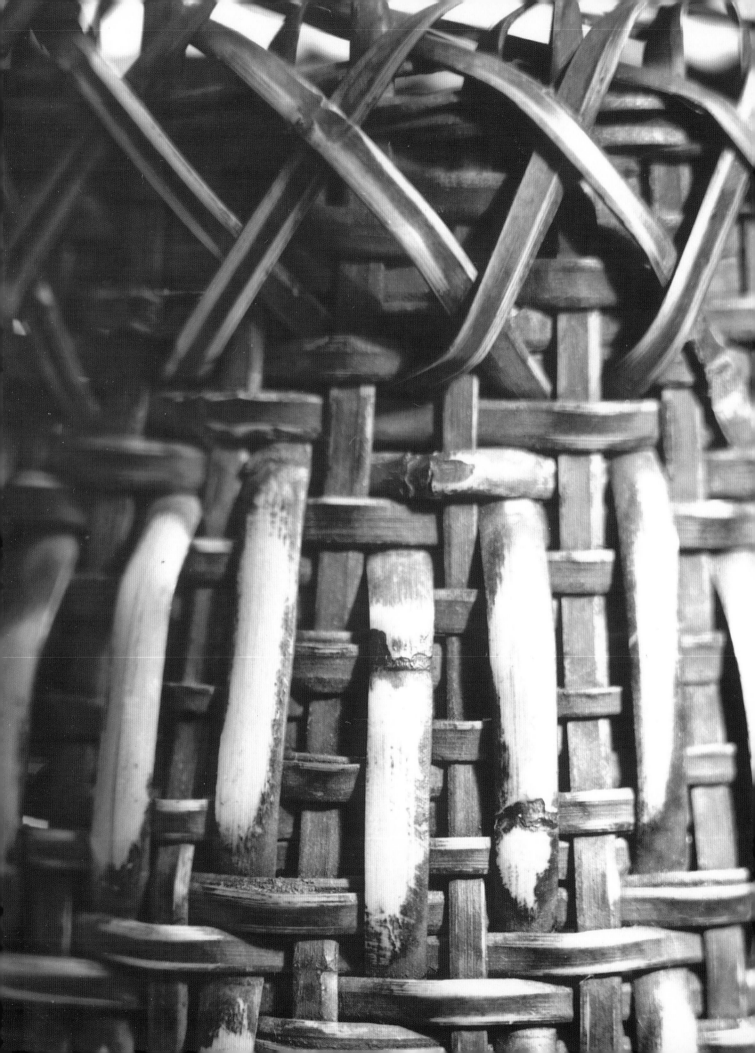

Sources

Retail, Wholesale, Galleries

Arise Gallery
6925 Willow Street, NW
Washington, DC 20012
(202) 291-0770
kimono, obi, tansu, hibachi, screens,
baskets, porcelain, prints

Art Asia, Inc.
1088 Madison Avenue
New York, NY 10028
(212) 249-7250
baskets, kimono, obi, lacquerware,
porcelain, furniture

Asakichi
1730 Geary Boulevard
San Francisco, CA 94115
(415) 921-2147
Japanese accesories, teapots

Asia Gallery
1220 First Avenue
Seattle, WA 98101
(206) 622-0516
antiques, baskets, furniture,
porcelain, folk art

Brooklyn Botanic Garden
1000 Washington Avenue
Brooklyn, NY 11225
(718) 622-4433
Japanese garden; Annual
Cherry Blossom Festival,
April 30 & May 1

Bunka-Do
340 East First Street
Los Angeles, CA 90012
(213) 625-8673
folk art, ceramics

The Crane Gallery, Inc.
1203B Second Avenue
Seattle, WA 98101
(206) 622-7185
various Asian arts, baskets, antiques

Eastern Dreams
6 Greenridge Drive
Chappaqua, NY 10514
(914) 666-8910
by appointment only: ikebana
planters, porcelain, yukata,
lacquerware, paper and wood
crafts, contemporary screens

Flying Cranes Antiques Ltd.
Manhattan Art & Antiques
Center
1050 Second Avenue
Galleries 55 & 56
New York, NY 10022
(212) 223-4600
Fax: (212) 223-4601
international source for Oriental
antiques, including Japanese
porcelains, Satsuma, metalwork,
cloisonne, ikebana baskets, and ivory
and wood carvings; also specializes
in antique Japanese weaponry,
Chinese Rose Canton, and furniture

Gordon Foster
1322 Third Avenue
New York, NY 10021
(212) 744-4922
baskets, antiques, porcelain

Dodi Fromson Antiques
P.O. Box 49808
Los Angeles, CA 90049
(310) 451-1110
Fax: (310) 395-5737
by appointment: antiques, textiles,
bronzes, metalwork, lacquerware

Ginza
1721 Connecticut Avenue, NW
Washington, DC 20008
(202) 331-7991
antiques, kimono, folk art, porcelain,
crafts, futons

Gump's
250 Post Street
San Francisco, CA 94108
(415) 982-1616
antiques, furniture

Harper Galleries/Bijutsu, Inc.
4 Via Parigi
Palm Beach, FL 33480
(407) 655-8490
traditional furnishings, art,
and accessories

Jōmon Gallery
550 Madison Avenue
New York City 10022
(212) 935-1089
traditional craftwork

Kagedo
520 First Avenue, South
Seattle, WA 98104
(206) 467-9077
antiques

Kimono House
120 Thompson Street
New York, NY 10012
(212) 966-5936
kimono, obi, antiques, ceramics

Koho
School of Sumi-E
64 MacDougal Street
New York, NY 10012
(212) 673-5190
 533-4608
Japanese brush painting
and calligraphy classes

Koto
71 West Houston
New York, NY 10012
(212) 533-8601
kimono, pottery

The Kura
310 Rockrimmon Road
Stamford, CT 06903
(203) 329-1778
by appointment: hibachi, tansu,
lamps, obi, baskets, screens

Kuromatsu
722 Bay Street
San Francisco, CA 94109
(415) 474-4027
baskets, antiques

Ross Levett Antiques
Tenants Harbor, ME 04860
(207) 372-8407
antiques

McMullen's Japanese
Antiques
146 N. Robertson Boulevard
Los Angeles, CA 90048
(310) 652-9492
baskets, antiques

Mikado
1737 Post Street
Suites 8, 9, & 10
San Francisco, CA 94115
(415) 922-9450
kimono, interior decorations

Mills Gallery
583 Kamoku Street
Honolulu, HI 96826
(808) 951-0640
by appointment: interior design

Miya Shoji and Interiors
109 West 17th Street
New York, NY 10011
(212) 243-6774
Fax: (212) 243-6780
shoji screens and wood carpentry

Naga Antiques Ltd
145 East 61st Street
New York, NY 10021
(212) 593-2788
Fax: (212) 308-2451
ikebana baskets

Old Japan
382 Bleecker Street
New York, NY 10014
(212) 633-0922
Japanese antiques and mingei

Oriental Treasure Box
Olde Cracker Factory
Antique Shopping Center
448 W. Market Street
San Diego, CA 92101
(619) 233-3831
tansu, folk art, porcelain, hibachi

Ronin Gallery
605 Madison Avenue
New York, NY 10022
(212) 688-0188
Japanese art, baskets

Sanpho Corporation
189 State Street
Boston, MA 02109
(617) 720-5370
*wholesale; prints, paper,
porcelain, hibachi*

Shibumi Trading, Ltd
P.O. Box 1-F
Eugene, OR 97440
800-843-2565
(503) 744-1832
*wholesale for Japanese gardens:
bamboo fencing, water hammer
and faucet sets, granite, stone, art*

Soko Interiors
1672 Post Street
San Francisco, CA 94115
(415) 922-4155
*folkcraft, furniture, lacquerware,
porcelain*

Takahashi Oriental Decor
235 15th Street
San Francisco, CA 94103
(415) 552-5511
*tansu, screens, furnishings, shoji,
ceramics, obi bronzes*

Takashimaya America, Inc.
693 Fifth Avenue
New York, NY 10022
(212) 350-0100
The Gallery at Takashimaya
(212) 350-0115
*Japanese furnishings, antiques,
housewares, ceramics, clothes, gifts,
lacquerware*

Things Japanese
127 East 60th Street
2nd floor
New York, NY 10022
(212) 371-4661
*Japanese furniture, baskets, scrolls,
masks, screens, folk art, textiles*

Uwajimaya
519 6th Avenue S.
Seattle, WA 98108
(206) 624-6248
*ikebana baskets, washi, shoji lamps,
kimono, noren*

Vilunya Folk Art
Charles Square
5 Bennett Street
Cambridge, MA 02138
(617) 661-5753
folk art, kimono, obi, lacquered boxes

Zen Oriental Book Store
521 Fifth Avenue
New York, NY 10175
(212) 697-0840
Fax: (212) 983-1765
*books, CDs and tapes, gifts
(including sake and tea sets),
folk art*

Museums

Asian Art Museum of
San Francisco
Avery Brundage Collection
Golden Gate Park
San Francisco, CA 94118-4598
(415) 668-8921

Brooklyn Museum
200 Eastern Parkway
Brooklyn, NY 11238
(718) 638-5000

John P. Humes Japanese
Stroll Garden
P.O. Box 671
Locust Valley, NY 11560
(516) 676-4486

Los Angeles County
Museum of Art
Japanese Pavillion
5905 Wilshire Boulevard
Los Angeles, CA 90036
Shops: (213) 857-6146, 6520

Metropolitan Museum of Art
Japanese Gallery
Fifth Avenue at 82nd Street
New York, NY 10028
(212) 879-5500

Mingei International
Museum of World Folk Art
4405 La Jolla Village Drive
Bldg. 1-7
San Diego, CA 92122
(619) 453-5300

Morikami Museum and
Japanese Gardens
4000 Morikami Park Road
Delray Beach, FL 33446
(407) 832-3461

Museum of Fine Arts, Boston
465 Huntington Avenue
Boston, MA 02115
(617) 267-9300

New Orleans Museum of Art
City Park
New Orleans, LA 70100
(504) 488-2631

Peabody Museum of Salem
161 Essex
Salem, MA 01970
(617) 745-9500

Seattle Art Museum
14th East and East Prospect
Seattle, WA 98100
(206) 625-8900

Smithsonian Institution
Freer Gallery of Art
Jefferson Dr. at 12th St., SW
Washington, DC 20560
(202) 357-1300 museum
(202) 357-1429 museum shop

The Textile Museum
2320 S Street, NW
Washington, DC 20008
(202) 667-0441

Organizations

The Japan Society
333 East 47th Street
New York, NY 10017
(212) 752-3015
Fax: (212) 715-1262

Urasenke, Inc.
School of Tea
153 East 69th Street
New York, NY 10021
(212) 988-6161

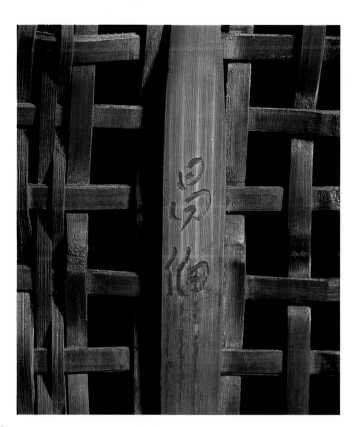

BIBLIOGRAPHY

Fukioka, Ryoichi with Masaki Nakano, Hirokazu Arakawa, and Seizo Hayashiya. *Tea Ceremony Utensils*. New York: Weatherhill/Shibundo, 1973.

Fukukita, Yasunosuke. *Tea Cult of Japan*. Tokyo: Japan Travel Bureau, 1961.

Haas, Robert, editor. *The Essential Haiku, Versions of Bashō, Buson, & Issa*. Hopewell, NJ: The Ecco Press, 1994.

Hammitzsch, Horst. *Zen in the Art of the Tea Ceremony*. New York: Penguin Books U.S.A., 1993.

Koehn, Alfred. *The Way of Japanese Flower Arrangement*. Tokyo: Kyo Bun Kwan, 1937.

Komoda, Shusui and Horst Pointner. *Ikebana, Spirit & Technique*. Poole, Dorset: Blandford Press Ltd., 1980.

Kudo, Kazuyoshi. *Japanese Bamboo Baskets*. Tokyo: Kodansha International, 1980.

Mahoney, Jean and Peggy Landers Rao. *At Home with Japanese Design*. Tokyo: Shufunotomo Co. Ltd., 1990.

McCallum, Toshiko M. *Containing Beauty, Japanese Bamboo Flower Baskets*. Los Angeles: UCLA Museum of Cultural History, 1988.

McClure, F. A. *The Bamboos*. Washington, DC: Smithsonian University Press, 1993 (reprint). First edition, Boston: Harvard University, 1966.

Ming-Dao, Deng. *365 Tao Daily Meditations*. San Francisco: Harper San Francisco, 1992.

Mitford, A. B. Freeman, *The Bamboo Garden*. New York: Macmillan & Company, 1896.

Mittwer, Henry. *Zen Flowers, Chabana for the Tea Ceremony*. Rutland, VT: Charles E. Tuttle Company, 1974.

Ohno, Noriko. *The Poetry of Ikebana*. Tokyo: Kodansha International, 1990.

Okada, Kozan. *Ikebana with the Seasons*. Tokyo: Shufunotomo Co., Ltd., 1989.

Okakura, Kakuzo. *The Book of Tea*. Tokyo: Kodansha International, 1989.

Recht, Christine and Max F. Wetterwald. *Bamboos*. Portland, OR: Timber Press, 1992.

Rexroth, Kenneth. *One Hundred More Poems from the Japanese*. New York: New Directions Publishing Corporation, 1976.

Sen, Soshitsu. *Chado, The Japanese Way of Tea*. New York: Weatherhill/Tankosha, 1979.

Steere, Dr. William C., editor. *Flower Arrangement: The Ikebana Way*. Tokyo: Shufunotomo Co., Ltd., 1972.

Stern, Harold P. *Birds, Beasts, Blossoms, and Bugs*. New York: Harry N. Abrams, 1976.

Stryk, Lucien and Takashi Ikemoto, translators, with the assistance of Taigan Takayama, Zen Master. *Zen Poems of China and Japan, The Crane's Bill*. New York: Grove Weidenfeld, 1973.

Suzuki, Daisetz T. *Zen and Japanese Culture*. Princeton, NJ: Princeton University Press, 1959.

Teshigahara, Sofu. *Ikebana, Sogetsu Flower Arrangement*. Washington, DC: Ikebana International, 1962.

Ueda, Makoto. *Matsuo Bashō*. Tokyo: Kodansha International, 1982.

Wood, Mary Cokely. *Flower Arrangement Art of Japan*. Rutland, VT: Charles E. Tuttle Company, 1951.

Yasuda, Kenneth. *The Japanese Haiku*. Rutland, VT: Charles E. Tuttle Company, 1957.

Discover Japan, Words, Customs and Concepts, Vol. 1. Tokyo: Kodansha International, 1982.

Discover Japan, Words, Customs and Concepts, Vol. 2. Tokyo: Kodansha International, 1987.

CREDITS

The baskets and other collectables in this book appear through the courtesy of the following galleries, stores, institutions, and private collectors:

FRONT COVER: Basket (height: 18 in., 46 cm) and screen from Things Japanese

BACK COVER: Basket (height: 14½ in., 37 cm; diameter: 16 in., 41 cm) from Naga Antiques, Ltd.; scroll from Things Japanese; fabric from the private collection of Cyril Nelson

TITLE PAGE: Baskets from Naga Antiques, Ltd. and Things Japanese

PAGE 8 Basket (height: 28 in., 71 cm) from Naga Antiques, Ltd.

CHAPTER I

PAGE 10–11, 12 Photos taken at the Urasenke Chanoyu Center, New York, NY

PAGE 15 Basket (height: 18¼ in., 46 cm) from early Meiji era, circa 1870s, from Takashimaya America, Inc.

PAGE 16 Basket (height: 15 in., 38 cm) from Flying Cranes Antiques, Ltd.

page 17 Basket (height: 6½ in., 17 cm; width: 2 in., 5 cm) from Ronin Gallery

PAGE 18–19 Basket (height: 16 in., 41 cm) and screen from Things Japanese

PAGE 20 Basket (length: 17 in., 43 cm) from Flying Cranes Antiques, Ltd.

PAGE 21 Basket (height: 20½ in., 52 cm) from Things Japanese

PAGE 22 Photo taken at the Urasenke Chanoyu Center, New York, NY

PAGE 23 Basket from Things Japanese

PAGE 24, 25 Photos taken at the Urasenke Chanoyu Center, New York, NY

PAGE 27 Basket (height: 15 in., 38 cm; width: 3 in., 8 cm) from Ronin Gallery

PAGE 28 Basket (height: 9 in., 23 cm; diameter: 3 in., 8 cm) from Ronin Gallery. Kimono from the private collection of Cyril Nelson

PAGE 29 Photo taken at the John P. Humes Japanese Stroll Garden, Mill Neck, NY

PAGE 30 Basket (height: 17½ in., 44 cm) from early Meiji era, circa 1870s, and tray from Takashimaya America, Inc.

PAGE 31 Basket (height: 12 in., 30 cm) from late Meiji era, circa 1910s, from Takashimaya America, Inc.

PAGE 32 Basket (height: 10½ in., 27 cm) from the private collection of Marta Hallett; lamp from Takashimaya America, Inc.

PAGE 33 Basket (height: 26½ in., 67 cm) from Naga Antiques, Ltd.; screen from Things Japanese

CHAPTER 2

PAGE 34–35, 36, 39 Photos taken at John P. Humes Japanese Stroll Garden, Mill Neck, NY

PAGE 40–41 Basket (height: 14½ in., 37 cm; diameter 16 in., 41 cm) from Naga Antiques, Ltd.; scroll from Things Japanese; fabric from the private collection of Cyril Nelson

PAGE 43 Basket (height: 18 in., 46 cm; diameter: 6½ in., 17 cm) from Flying Cranes Antiques, Ltd.

PAGE 44 Basket (height: 15½ in., 39 cm) from early Meiji era, circa 1870s, from Takashimaya America, Inc.

PAGE 45 Basket from Things Japanese

PAGE 47 Basket (diameter: 11½ in., 29 cm) from Flying Cranes Antiques, Ltd.

PAGE 48 Basket (height: 10 in., 25 cm; diameter: 7 in., 18 cm) from Flying Cranes Antiques, Ltd.

PAGE 49 Basket (height: 15 in., 38 cm) from Flying Cranes Antiques, Ltd.

PAGE 50 Basket (height: 17 in., 43 cm) from Flying Cranes Antiques, Ltd.

PAGE 53 Baskets (height: 16½ in., 42 cm and 20 in., 50 cm) and scroll from Things Japanese

PAGE 54–55 Tobacco case (height: 4¼ in., 11 cm) and bento basket (height: 8 in., 20 cm) from Naga Antiques, Ltd.

PAGE 57 Basket (height: 17½ in., 44 cm) from Naga Antiques, Ltd.

CHAPTER 3

PAGE 60 Basket (height: 14 in., 36 cm) from the late Meiji era, circa 1910s, from Takashimaya America, Inc., scroll from Things Japanese

PAGE 63 Basket (height: 27 in., 69 cm) from Naga Antiques, Ltd.; nineteenth-century gourd (height: 14½ in., 37 cm) from Things Japanese

PAGE 64 Basket (height: 20 in., 51 cm) from Meiji era, from Takashimaya America, Inc. Kimono from the private collection of Cyril Nelson

PAGE 66 Rattan hat with signature in bamboo (height: 5½ in., 14 cm) circa 1850–1875, from Naga Antiques, Ltd.; screen and umbrella from Things Japanese

PAGE 68 Baskets (height: 11 in., 28 cm and 13 in., 33 cm) from the early Meiji era, circa 1870s, from Takashimaya America, Inc.

PAGE 71 Basket (height: 25 in., 64 cm), from the early Meiji era, circa 1870s, steel balls, and plate from Takashimaya America, Inc.

PAGE 72 Basket (height: 8½ in., 22 cm; inside diameter: 3½ in., 9 cm; outside diameter: 8½ in., 22 cm) from Ronin Gallery

PAGE 74 Basket (height: 16½ in., 42 cm; diameter: 19½ in., 50 cm) from the early Meiji era, circa 1870s, from Takashimaya America, Inc.

PAGE 77 Basket from Flying Cranes Antiques, Inc.

PAGE 78–79 Basket (height: 9½ in., 24 cm; length: 15 in., 38 cm; width: 6 in., 15 cm) from Ronin Gallery

PAGE 81 Basket (height: 17 in., 43 cm) from Flying Cranes Antiques, Ltd.

PAGE 82 Basket (height: 9 in., 23 cm; diameter: 12 in., 30 cm) from Naga Antiques, Ltd.

PAGE 84 Basket (height: 9½ in., 24 cm) circa 1920s, from Old Japan; pillow from Takashimaya America, Inc.

PAGE 86 Basket (height: 20½ in., 52 cm) from Flying Cranes Antiques, Ltd.

PAGE 87 Basket (height: 11 in., 28 cm) from Flying Cranes Antiques, Ltd.

CHAPTER 4

PAGE 88–89 Basket (height: 12 in., 30 cm; diameter 13 in., 33 cm) from Flying Cranes Antiques, Ltd.

PAGE 90 Basket (height: 6 in., 15 cm; width: 9 in., 23 cm) from the private collection of Mutsuo Tomita

PAGE 92–93 Basket (height: 4 ½ in., 11 cm; length: 7½ in., 19 cm; width: 5¾ in., 15 cm) from Flying Cranes Antiques, Ltd.

PAGE 94 Basket (height: 15 in., 38 cm; length: 9½ in., 24 cm; width: 6 in., 15 cm) from Ronin Gallery

PAGE 95 Basket (height: 19 in., 48 cm) from Flying Cranes Antiques, Ltd.

PAGE 96 Basket from Things Japanese

PAGE 99 Basket from Things Japanese

PAGE 100–101 Basket from Things Japanese

PAGE 102 Basket (height: 10 in., 25 cm; diameter: 7 in., 18 cm) from Flying Cranes Antiques, Ltd.

PAGE 104–105 Basket (height: 15 in., 38 cm; diameter: 14 in., 36 cm) from Flying Cranes Antiques, Ltd.

PAGE 106 Basket from Things Japanese

PAGE 107 Basket from Things Japanese

CHAPTER 5

PAGE 108–109 Basket (diameter: 14½ in., 37 cm) from early Meiji era, circa 1870s, from Takashimaya America, Inc.

PAGE 110 Basket (height: 15 in., 38 cm.; diameter: 3 in., 8 cm) from Ronin Gallery

PAGE 118, 120–121 Basket (diameter: 14½ in., 37 cm) from the early Meiji era, circa 1870s, and pillow from Takashimaya America, Inc.

PAGE 122, 124–125 Basket (height: 16½ in., 42 cm) from Takashimaya America, Inc.

PAGE 126, 128–129 Basket from the private collection Starr Lawrence; statue from the collection Yi-An Chou

PAGE 130, 132–133 Basket (height: 9½ in., 24 cm) circa 1920s, from Old Japan

PAGE 134, 136–137 Basket from the private collection of Starr Lawrence

Index